MORGANTOWN

Opposite: Here is an aerial view of Morgantown, West Virginia, around 1950. Morgantown's population was steadily growing, as attested by the 1950 census count of 25,525 residents contrasted with the 1940 count of 16,655. Americans were buying goods that were restricted during World War II, which boosted the economy, however, the demand for coal in the postwar era dropped, and Morgantown saw a decline in jobs in the coal industry. But the end of the war also enabled thousands of veterans to take advantage of the GI Bill and attend college, and West Virginia University had one of the most explosive periods of growth in its history. (Morgantown Public Library.)

MORGANTOWN

Shannon Colaianni Tinnell

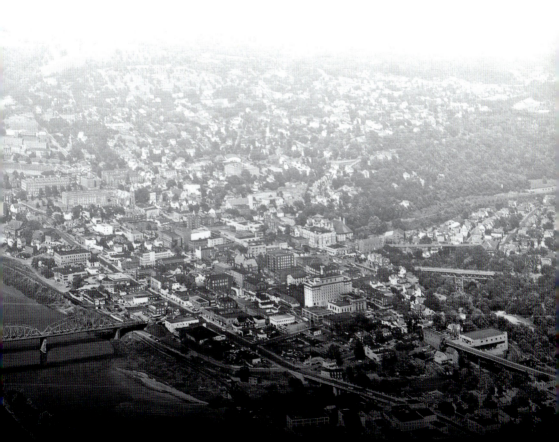

For Bobby, Isabella, Jack, and Giallo

Copyright © 2011 by Shannon Colaianni Tinnell
ISBN 978-0-7385-8812-4

Library of Congress Control Number: 2011928161

Published by Arcadia Publishing
Charleston, South Carolina

Printed in the United States of America

For all general information, please contact Arcadia Publishing:
Telephone 843-853-2070
Fax 843-853-0044
E-mail sales@arcadiapublishing.com
For customer service and orders:
Toll-Free 1-888-313-2665

Visit us on the Internet at www.arcadiapublishing.com

ON THE FRONT COVER: Here is the Monongalia County Courthouse as it appeared in 1911. The courthouse is located on High Street between Pleasant and Walnut Streets and still serves the people of Monongalia County—not only in judicial matters but also for research, especially in the area of wills and deeds. (West Virginia and Regional History Collection, West Virginia University Libraries.)

ON THE BACK COVER: Here is the christening ceremony of the Capitaliner Morgantown plane at Morgantown Municipal Airport in 1949. In the picture, from left to right, are Florence Stewart, Gov. Oakey Patteson, and Jack Fleming. Stewart was the wife of Irvin Stewart, who served as president of West Virginia University (WVU) from 1946 to 1958. West Virginia's 23rd governor, Patteson was instrumental in establishing the first medical school in West Virginia at WVU, and in recognition of his efforts, a portion of WV Route 705 was named Patteson Drive. Beloved sports announcer Fleming was not only the voice of West Virginia Mountaineer football and basketball teams for decades but also called play-by-play for the Pittsburgh Steelers. Among many highlights in his career, Fleming called what the National Football League called "the greatest play of all time": Franco Harris's controversial 1972 catch dubbed the "Immaculate Reception," which allowed the Steelers to defeat the Oakland Raiders and advance to a first-ever American Football Conference Championship appearance. (Bill Rumble.)

Contents

Acknowledgments vii
Introduction ix
1. Transportation and Infrastructure 11
2. Business and Industry 31
3. Life in and around Morgantown 55
4. Education 75

Acknowledgments

This book was created from historical pictures and postcards graciously shared with me by many in the Morgantown community. I'm so grateful and privileged to have had the pleasure to utilize these images, as well as hear the local history that accompanied each of them. A big thank you to Bobby Bice, Dr. Barbara Rasmussen, Bill Rumble, Lynn Stasick, the Morgantown Municipal Airport, West Virginia University, the Morgantown Public Library, and the Aull Research Center. I am particularly grateful to Larry Sypolt and Rodney Pyles, both of whom generously offered help and encouragement throughout this process. They not only shared wonderful old pictures and historical information with me, they also helped proofread the book. I am eternally grateful to all the local historians who left a vast, invaluable wealth of knowledge that continues to teach me so much. This book would have not been possible without Earl Core's *The Monongalia Story*. His contribution to Monongalia history is priceless and reinforces the notion that "all history starts as local history."

A very special thank you to Addie Glotfelty for all the time and love she put into shooting the present-day photographs for the project. I couldn't have done it without you! (Unless noted otherwise, all present-day images are courtesy of Addie Glotfelty.)

My deepest gratitude and love to my family, who tolerated many meals around a cluttered dining room table covered with images and a house that, on many days, looked more like a research facility than a home. And, finally, to my loving husband for inspiring me to push forward on days when I had writer's block, for playing detective with me, and always being my biggest fan—thank you!

Introduction

Morgantown, the county seat of Monongalia County, West Virginia, occupies gently sloping ground bordered by the foothills of the Appalachian Mountains and the ancient river the Algonquin (Delaware) Indians called *Mechmenawungihilla*, which means "river of crumbling banks" or "high banks that fall down." Today, this river is known as the Monongahela or, as referred to by locals, "the Mon." The Mon flows northward from Morgantown to Pittsburgh, Pennsylvania, where it joins the Allegheny River to form the Ohio River. It is part of the country's tremendous system of transport that is the Mississippi River watershed. Being a river with the potential for navigation, feeding into the heartland of America, and situated amongst vast natural resources ensured that the Monongahela River would play a powerful role in American history. It makes perfect sense then, given its location adjacent to the river, that Morgantown's fortunes would be inextricably tied to the Mon.

Prior to the mid-18th century, the area surrounding what is now Morgantown was the provenance of Native Americans and French traders. It was not until 1758 that Tobias Decker and a small party of settlers from the English colonies to the east ventured into present-day Monongalia County, settling an area along what is now known as Decker's Creek. It was a short-lived attempt, for Delaware Indians attacked the settlers in 1759; the survivors fled back East. The Decker incident remains a clear example of the ongoing tension that resulted from English colonists' desire for new land and the Native Americans and French opposing that expansion. Those troubles, among others, led to the French and Indian War, and the resultant British victory revived expansion efforts by the colonists. Col. Zackquill Morgan arrived in the area around 1768 but did not attempt permanent settlement until 1772. Trouble with Native Americans continued, and by 1773, Morgan built a stockade fort. In 1785, the Virginia Assembly granted a formal charter to the settlement, which came to be known as "Morgan's Town."

Throughout the late 18th century, Morgantown remained an agricultural community whose chief form of economic activity was the barter system. This condition existed primarily due to a lack of easy transportation, which in turn led to difficulties with banking and political representation. Simply put, there were no banks, no ready cash, and the center of state government was hundreds of miles away. Certainly, at that time, the Monongahela River represented transport to Pittsburgh and points beyond the frontier, as well as the potential for much more in the future if its flows could be stabilized. But the markets for goods were back East, over the mountains, and such travel was difficult. In fact, difficulty in transportation was the major reason the area's corn growers took to distilling whiskey, which was much easier to transport than bulk crops and was in high demand. It was said that this local liquor, known as Monongahela Rye, was a favorite of Russia's czar in that era. Over the decades between the Revolutionary and Civil Wars, the frontier moved westward, and other infrastructure improvements were made, enabling Morgantown to grow, albeit slowly, beginning with the opening of the road to Pittsburgh in the late 1790s. The year 1814 saw the first bank in Monongalia County open, and in 1838, the Virginia General Assembly finally incorporated the town as the Borough of Morgantown. In 1863, amidst the turmoil of the Civil War, Monongalia joined other counties from across the mountains to secede from Virginia and form the new state of West Virginia, which greatly contributed to Morgantown's ability to politically influence its future. It was not until the close of the 19th century, however, that growth would explode.

It can be said that Morgantown's destiny has been driven by education, beginning in 1814 with the formation of the Monongahela Academy. Then, in 1858, the Woodburn Female Seminary opened. But the event that may well be called the defining moment in the city's history would not occur until 1867 as a direct result of the Morrill Act of 1862. According to Earl Core's *The Monongalia Story*, the Morrill Act was also known as the Land Grant College Act, and it delivered a major boost to higher education in the United States by encouraging the establishment of institutions in each state to educate people in agriculture, home economics, mechanical arts, and other professions that were deemed practical at the time. In 1867, Monongahela Academy and Woodburn Female Seminary were given to the state to form the Agricultural College of West Virginia, and in 1868, the newly combined college was renamed West Virginia University.

Despite the development of educational institutions, timbering operations, and industrial ironworks and potteries, Morgantown remained a predominantly agricultural area with slow growth, and, as before, insufficient transportation routes were the reason. The young but quickly growing United States had developed major east-to-west roads—the National Road and the Northwestern Turnpike—but both of them bypassed Morgantown. To make matters worse, the only roads connecting Morgantown to these main arteries of transportation were small, ill kept, and at the mercy of the seasons. In 1886, the Baltimore & Ohio (B&O) Railroad finally reached Morgantown, delivering with it a wealth of opportunity for the flow of goods and people. The legendary Monongahela River, however, still had not reached its potential, suffering from a lack of the locks and dams needed to achieve consistency of transport by stabilizing the river's level and flow. This was particularly frustrating as new markets had become available downriver. That is until 1890, when a series of locks and dams were constructed, providing an additional nine feet of slack water on the river, thus, improving water commerce to the Pittsburgh market and beyond. Now armed with two reliable modes of transport and fueled by the growth of area coal-mining operations, the city began attracting new industries—chief among them was glassmaking. Like so many American cities and industries benefiting from the Industrial Revolution, Morgantown recruited emigrants from Southern and Eastern Europe to work the mines, plants, and factories. With these emigrants came new languages, traditions, food, and culture, all of which enriched the city. The 1900 census credits Morgantown with a population of 1,895 people, with almost 3,500 residing in surrounding areas.

In 1901, the city annexed the nearby communities of Durbannah (South Morgantown), Seneca, and Greenmont, increasing Morgantown's population to 5,000. In 1905, East Morgantown joined the city, and by 1910, the population grew to 9,000 residents. In 1949, Suncrest and Sabraton were annexed, bringing the number of wards (districts represented on city council) to seven. By the early 21st century, the city's population, now including suburban Cheat Lake, soared to nearly 30,000, even as WVU's student population approached the same number. As of this writing, Monongalia County has a population of about 96,189 people when the WVU students are present.

Morgantown's current economic growth is at least partially fueled by a natural-gas boom, alongside the ever-present coal-mining and coal-burning power operations. But these traditionally Appalachian extractive industries do not define the city. That distinction is reserved for education, research, and medicine. The largest employers in Monongalia County are no longer coal mines and glass factories. Instead, they are West Virginia University, Mylan Pharmaceuticals, and the two area hospitals, Mon General and West Virginia University Hospital. The resultant diversified economy enables the city to have one of the lowest unemployment rates in the country, as well as being designated one of the best small cities in America.

CHAPTER 1

Transportation and Infrastructure

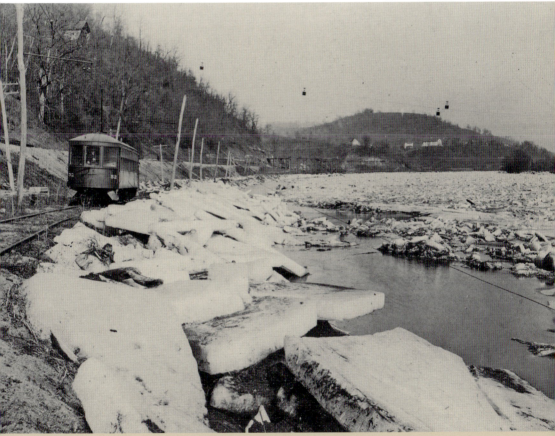

The Morgantown & Dunkard Valley Railroad constructed between 1910 and 1911 was powered by electricity and transported passengers to and from area coal mines. At the time this picture was taken by Morgantown photographer Scott Gibson in 1920, it had over eight miles of track that ran from Morgantown to Cassville alongside the Monongahela River. (Morgantown Public Library.)

Morgantown's old suspension bridge over the Monongahela River was built in 1854. Due to its strategic importance during the Civil War, it was used by both the Union and Confederate armies. Local lore suggests that the Confederate army tried to burn it down. It was an important link in the city's infrastructure, allowing Morgantown access to the west side of the river, which in turn helped fuel the development of the town of Westover. It was torn down in 1908 and replaced in 1909 by a new bridge, known locally as the Westover Bridge, which also was replaced in 1977. A small section of stone wall from the old suspension bridge can still been seen along the riverbank. (Morgantown Public Library.)

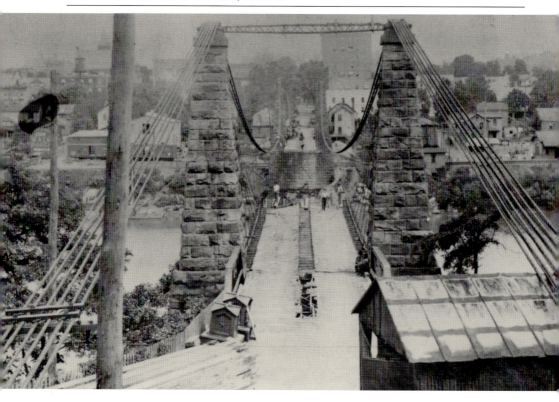

This bridge across Decker's Creek connected Morgantown to its newly developed, affluent suburb of South Park via Walnut Street. Today's Walnut Street bridge still serves the people of Morgantown but in an expanded capacity as a vital part of heavily traveled Route 7, which leads beyond South Park to Sabraton and beyond. (Rodney Pyles.)

TRANSPORTATION AND INFRASTRUCTURE

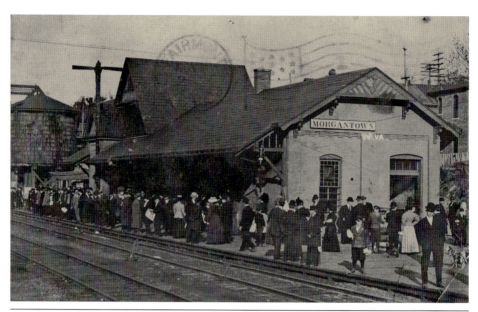

The Baltimore & Ohio Railroad Depot was constructed in 1885, coinciding with the completion of the railroad line running north to south along the Monongahela River and connecting Morgantown to Fairmont and points east. The first passenger train arrived in Morgantown on Valentine's Day 1886. The construction of the railroad represented a pivotal moment in Morgantown's growth and development. By 1894, the B&O reached the Pennsylvania state line and, in 1895, connected to Connellsville, Pennsylvania, thus, expanding access to the Pittsburgh markets. Currently, the depot serves as a bus terminal for Mountain Line, Monongalia County's publically funded transportation system. Mountain Line plays a critical role in the effort to lessen Morgantown's traffic congestion by providing affordable bus transportation to the community, as well as free transportation for senior citizens, high school students, and West Virginia University students. (Morgantown Public Library.)

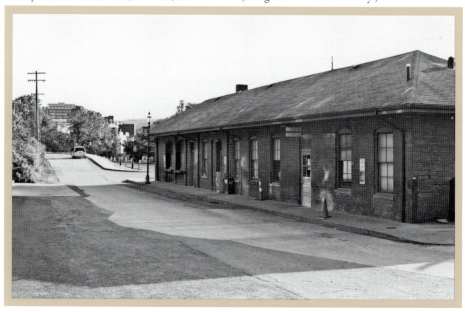

This is an old postcard of lock No. 10 on the Monongahela River. The lock was ordered to be built by the secretary of war between 1897 and 1904 to improve transportation on the Monongahela River. Before the locks and dams were built, the Monongahela River was at the mercy of the seasons and weather. In fact, at times, the river was shallow enough to walk across. The lock-and-gated dam secured a depth of nine feet of slack water, allowing year-round water transportation, most notably of coal, to the Pittsburgh market some 103 miles downriver. In the 1940s, a modernization program funded improvements, and a new dam was built in 1950 to more efficiently accommodate barges. (Rodney Pyles.)

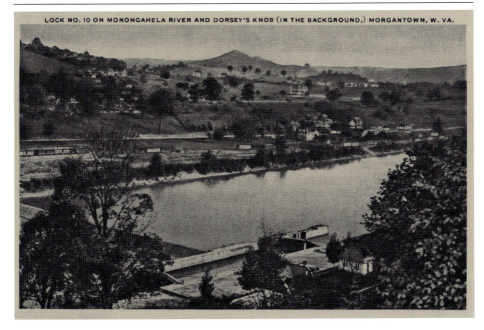

Transportation and Infrastructure

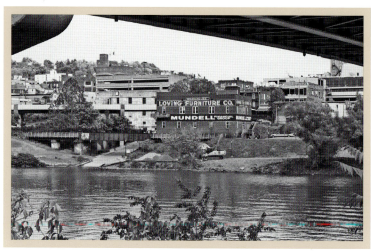

The Wharf and Warehouse District at the Walnut Street Landing was an important part of Morgantown's transportation and industrial history much earlier than when this photograph was taken in 1909. Boats and barges were loaded and unloaded at the wharf, and after the arrival of the railroad in 1885, the area served it as well as river traffic. Also present in the photograph are the Chaplin, Warman & Rightmire Lumber & Millwork and the old B&O Railroad trestle. Today the Wharf District is on the National Register of Historic Places and is a thriving business district. The railroad trestle still stands, and many of the old buildings have been successfully brought back to life by nonindustrial businesses, like the West Virginia Brewing Company. (Rodney Pyles.)

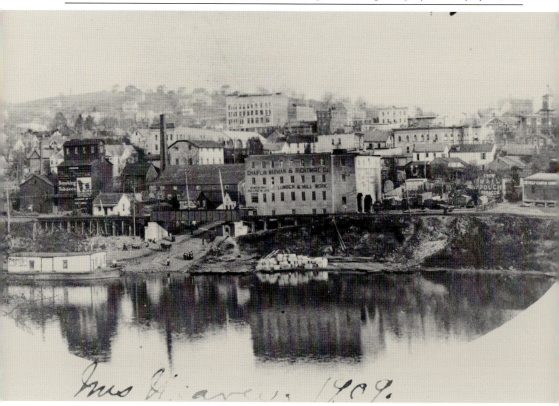

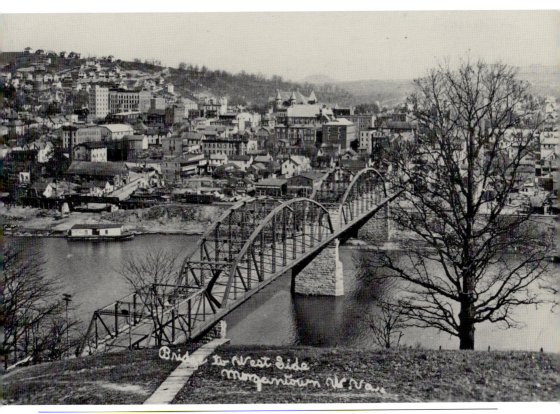

This is a westward view across the Monongahela River just before the old suspension bridge was torn down around 1908. A free ferry was established to transport people from one side of the river to the other while the old bridge was dismantled and the new one constructed. Today, the river remains an epicenter of leisure and commercial activity in Morgantown. (Rodney Pyles.)

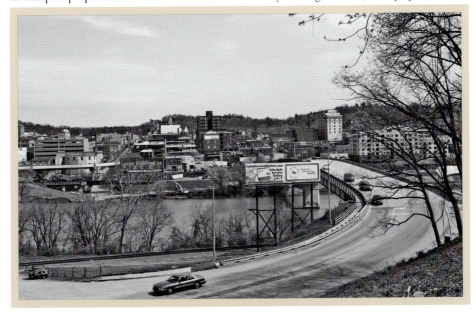

Transportation and Infrastructure

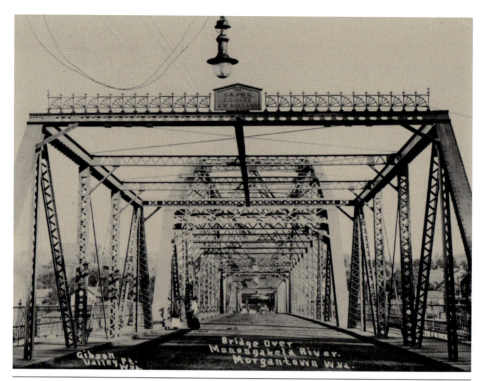

In 1908, the old suspension bridge was demolished, and the following year, this new structure was erected over the Monongahela River. At the time, the area west of the river was not incorporated and was simply called West Morgantown. Students would walk across the bridge to go to school at the Monongahela Academy. In 1911, the West Morgantown area was incorporated as Westover, and a public school was built for the newly independent community. As noted before, the third bridge to link Morgantown and Westover was constructed in 1977. In June 2011, the bridge that never had a formal name was finally and officially named the Joseph C. Bartolo Memorial Bridge, in honor of the former sheriff and Westover mayor. (Morgantown Public Library.)

Here is downtown Morgantown at the corner of Walnut and High Streets, as captured by a 1920s postcard. The town was investing heavily in infrastructure, especially in the realm of road building. Also in the picture are the tracks for the trolley developed by Morgantown Traction & Electric Company (1903) called the Loop Line, which ran until 1923 when the age of the automobile took over. Many of the old buildings still stand and have been converted into new businesses. (Morgantown Public Library.)

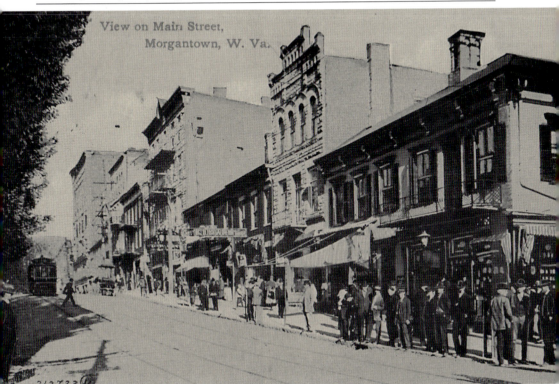

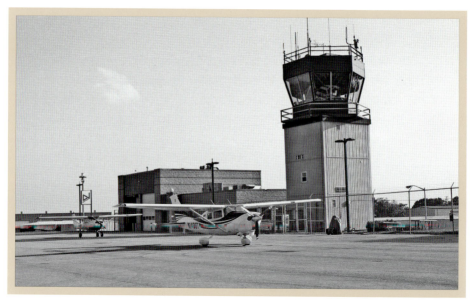

In 1935, the face of transportation in the city changed once again with construction of the Morgantown Municipal Airport. Work started in 1935 as a part of the Works Progress Administration (WPA) and was completed in 1937. Known today as Walter L. "Bill" Hart Field, the airport encompasses over 630 acres. In addition to private and chartered flights, United Express uses Hart Field's two runways with daily flights to Washington, DC. Today, the terminal features a full-service Mediterranean restaurant, Ali Baba's, a favorite among locals. (Bill Rumble.)

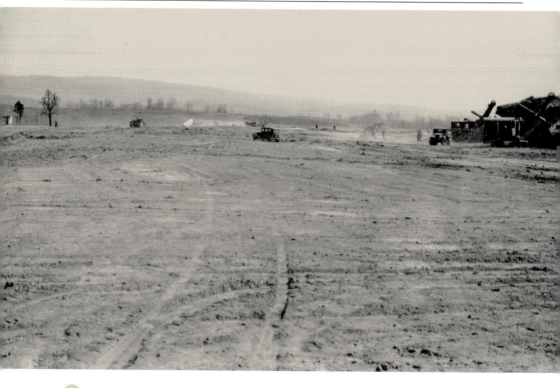

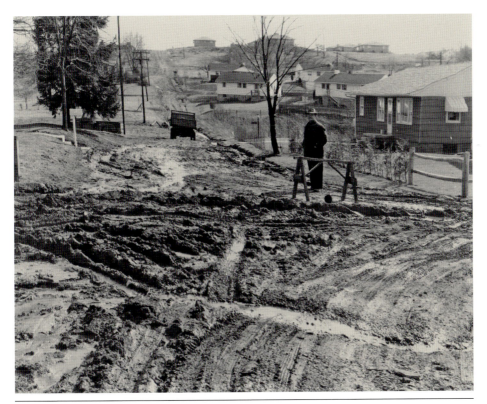

In 1923, the Monongahela Development Company purchased farmland belonging primarily to the Anderson and Krepp families and developed a residential area, tapping into Americans' growing infatuation with suburban living. The resulting neighborhood came to be known as Suncrest and was incorporated in 1937. In 1941, during World War II, the Defense Homes Corporation built over 100 homes for the employees of DuPont Morgantown Ordinance Works, which made ammonia for the war effort. In 1949, Suncrest was annexed by Morgantown. Today—given its proximity to the university, several research facilities, and both hospitals—Suncrest remains a very desirable Morgantown neighborhood. (Bill Rumble.)

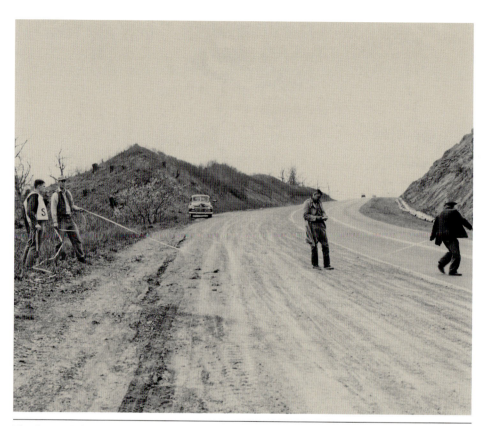

The location for the new medical school in Evansdale was over two miles away from the downtown campus of West Virginia University. Thus, the decision was made to relocate some of the county's major highways, with one being Route 19. The new route left downtown, following Beechurst Avenue up the hill to Evansdale, and traveled through Star City to Scott's Run and onto Mount Morris, Pennsylvania. This 1962 photograph shows people from the highway department widening Monongahela Boulevard as it climbs from downtown to Evansdale. (Bill Rumble.)

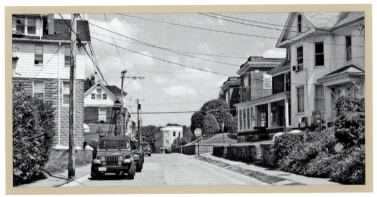

A Morgantown Public Works Department crew tears up concrete on Wilson Avenue in the Greenmont area of Morgantown in the early 1960s. The Greenmont area was home to one of Morgantown's founding families, the Kearns, who built a stockade fort there in 1774. Development of the neighborhood began in the 1860s, and Greenmont became a part of Morgantown in 1901. During the Industrial Revolution, many of Greenmont's inhabitants were immigrants and African Americans who found work in the industrial plants in the Sabraton area. Today, Greenmont is on the National Register of Historic Places and a strong Morgantown neighborhood. The Greenmont Neighborhood Association is comprised of area residents committed to maintaining the neighborhood's affordable and family-friendly identity. They hold a block party every summer as a way to familiarize residents with one another and strengthen neighborhood relations. An archaeological dig was recently started at the site of the old Kearn's Fort. (Bill Rumble.)

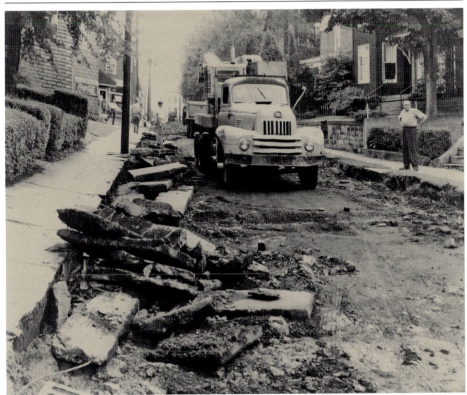

TRANSPORTATION AND INFRASTRUCTURE

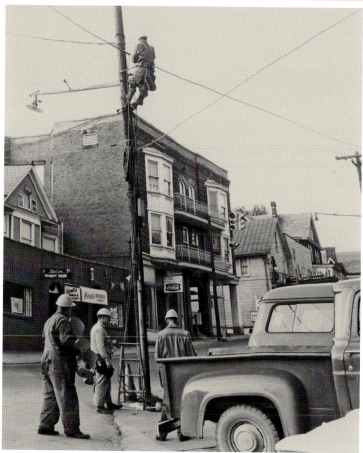

Morgantown Public Works Department crews install traffic signals on University Avenue at Stewart Street in 1962. Longtime fixtures of the city's Sunnyside neighborhood, these buildings still stand today and have retained much of their original character. West Virginia University students densely populate Sunnyside, and area businesses reflect that population, including popular watering holes, such as the Rusted Musket and Mutts. (Bill Rumble.)

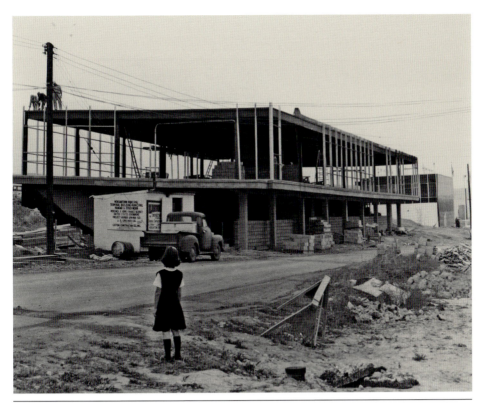

Here is Morgantown Municipal Airport's new terminal building as it was being constructed in 1963. In 1972, the airport was renamed for Walter L. Hart (legendary editor of the city's newspaper, the *Dominion Post*) in honor of his efforts on behalf of the facility. In 1976, the airport was annexed by the City of Morgantown. (Bill Rumble.)

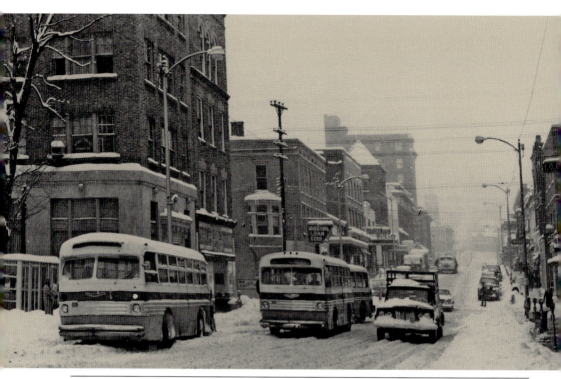

About 20 inches of snow fell on Morgantown during this 1964 storm. Bus service had replaced the streetcar line in 1928. The turreted building near the center of the photograph is the Berman Building, constructed in 1852 and used during the Civil War as the Confederate prison. To the left of the Berman Building are the Brown Building (1912) and the Bank of Morgantown Building (1920–1921). All of these buildings still stand and have retained much of their historical integrity. Today, the Mountain Line Transit bus service provides transportation to citizens and is free of charge to West Virginia University students. (Bill Rumble.)

TRANSPORTATION AND INFRASTRUCTURE

The road is being prepped to pave Woodlawn Avenue to Greendale Street in Suncrest at some point in the early 1960s. This young fisherman is heading toward Suncrest Lake, which no longer exists. The Morgantown Sanitary Board was created in 1964 to oversee the construction, maintenance, and management of a sewage disposal system. In 1965, one of five sewage treatment plants was constructed across from Suncrest Lake. (Bill Rumble.)

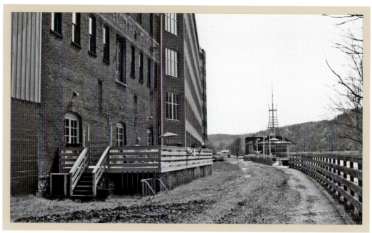

The railroad tracks were still in place behind Hugharts and the old Kincaid and Arnette Feed and Flour Building on Clay Street at the Wharf District in 1965. In place of the rails today is the six-mile-long Caperton Trail, an urban segment of the Mon River Trail system that stretches from the Pennsylvania state line to Prickett's Fort in Fairmont, West Virginia. Visitors to the trail, the recreational boating docks, or the Wharf District in general will find a number of thriving businesses, including Mountain State Brewing Company, The Wharf Restaurant, and Oliverio's Ristorante. The Wharf is also home to the Waterfront Place Hotel, the West Virginia University Administration Building, West Virginia Public Theatre, Centra Bank, Hughart's Heating and Cooling Supply, and many professional firms. (Bill Rumble.)

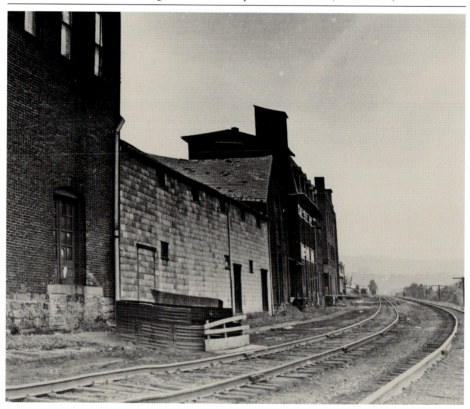

Paving continued in the former farmland of Suncrest, this time at the intersection of Aspen Street and Collins Ferry Road in 1969. The Suncrest area was believed to be at the bottom of Lake Monongahela, an ancient body of water that was formed during the last Ice Age and subsequently disappeared, in prehistoric times. Nearby was the site of a frontier blockhouse, Fort Burris, which was built in 1774 where the Summer's Masonic Lodge now stands at the intersection of Burroughs and Windsor Streets. (Bill Rumble.)

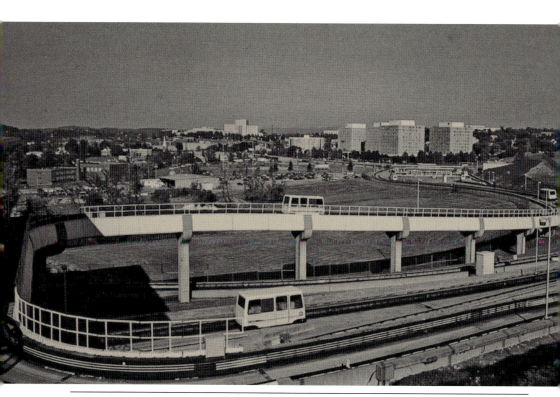

In 1975, the Personal Rapid Transit (PRT) system opened in Morgantown. Construction started in 1970 and was an ambitious project headed by West Virginia University professor Samy Elias, with funding from the Federal Transit Administration. With almost nine miles of tracks and five stations, the PRT is a one-of-a-kind people mover that connects the campuses of West Virginia University to downtown Morgantown. With valid West Virginia University identification, students and faculty ride for free; everyone else is charged 50¢. (Rodney Pyles.)

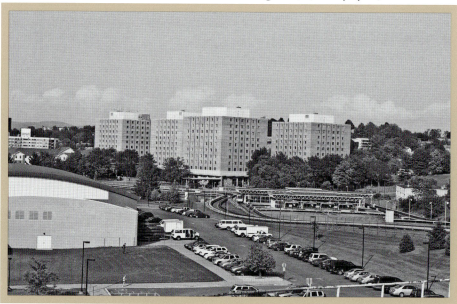

CHAPTER 2

BUSINESS AND INDUSTRY

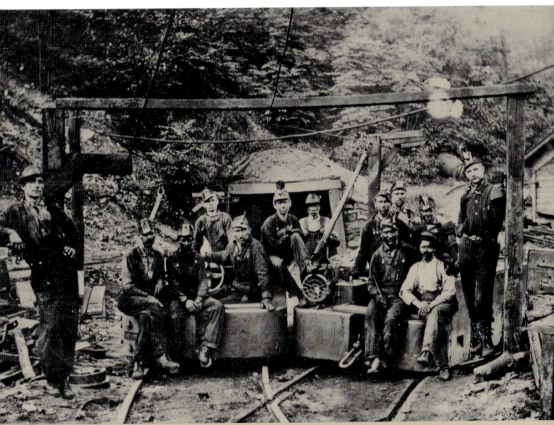

These miners dug coal for the Richard Mine sometime in the 1940s. The mine, located just outside of Morgantown, was started in 1903 by the Elkins Coal and Coke Company. The company built homes, a store, an office building, and many coke ovens. The mine closed in 1951. During this era, the population of Morgantown was still increasing, but at a much slower rate than in previous decades. This was due in part to the postwar decline in the coal industry and the mechanization of mining, which resulted in some people migrating out of state to find work, often in manufacturing jobs in Ohio and Michigan. (Rodney Pyles.)

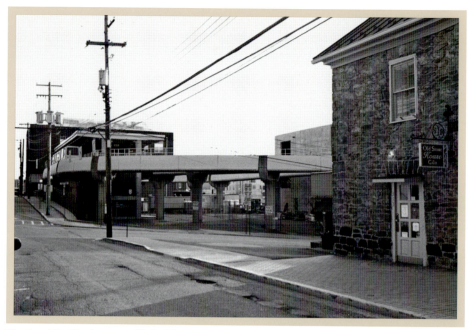

The Franklin Hotel was established by Fauquier Mcra in 1796 at the corner of Chestnut and Walnut Streets, but the site's history dates back to when it was the location of the Morgantown Fort and then a tavern and general store, contributing greatly to the survival and advancements of the pioneers. In 1841, Alexander Hayes bought the hotel and operated it until 1855, when it was sold to C.W. Finnell. Finnell sold the business to James Hopkins in 1876 but stayed on to run the hotel. The first business in town with an outside telephone line, the hotel also had a livery stable and ice plant. In 1899, it was sold to Walter and B.H. Madera, who razed the structure and built the Madera Hotel. It is now the site of the Chestnut PRT station. Across the street from the PRT station sits the Old Stone House gift shop. Built in 1796, the Old Stone House is one of the earliest structures in Morgantown and is listed on the National Register of Historic Places. (Morgantown Public Library.)

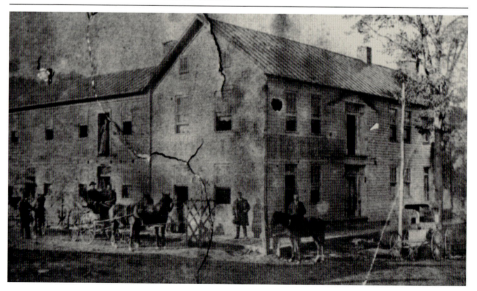

BUSINESS AND INDUSTRY

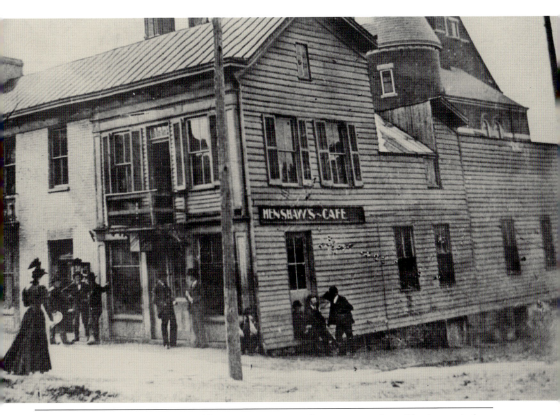

The Henshaw Café (1892) was owned by Burgess Henshaw, a prominent African American. Located at 258 High Street on the southwest corner of the intersection with Walnut Street, the site was home to a number of businesses in later years before housing the senior center and then the Monongalia Magistrate Court. (Morgantown Public Library.)

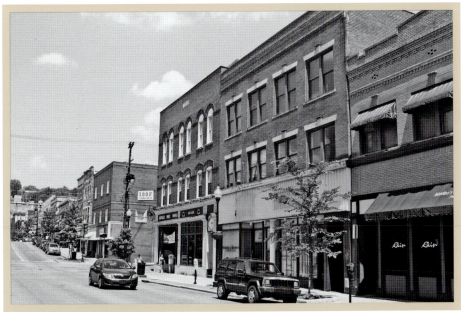

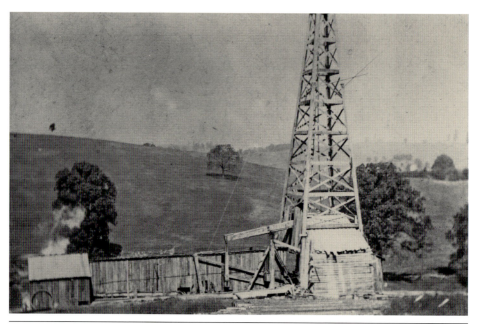

This oil well derrick is representative of the oil and gas industry boom, which took off in Monongalia County in 1888 in large part due to West Virginia University faculty member Dr. Israel C. White's anticlinal theory. White's geological theory advanced the notion that petroleum and natural gas migrate to the most elevated portions of permeable beds. In 1891, a pipeline was completed from Morgantown to Philadelphia, with the Morgantown tank field producing over 500,000 barrels daily. Today, the drilling industry is making a huge comeback in the area, owing to efforts to recover natural gas from the Marcellus Shale reserves utilizing deep horizontal wells. Drillers are able to retrieve the deep gas reserves in part by injecting large quantities of chemically treated fluids into the well in a process known as fracturing. In late June 2011, the Monongalia County Commission banned fracturing anywhere within a buffer area extending one mile beyond the Morgantown city limits in all directions, as well as within the city itself. This controversial decision came after a natural gas well employing fracturing was installed in close proximity to the source of Morgantown's drinking water. As of this writing, the ban is being challenged by a group of mineral rights owners. (Morgantown Public Library.)

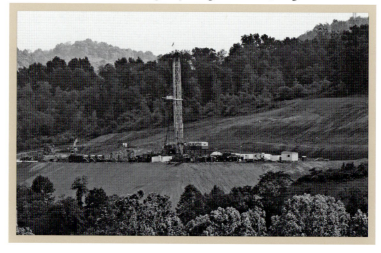

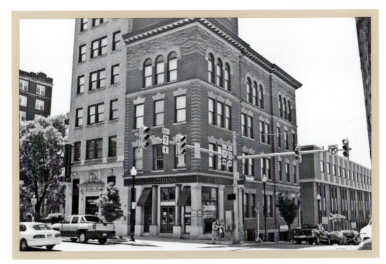

Posten's Sanitary Market was named for proprietor S.A. Posten, a prominent real estate developer who bought a frame structure at 295 High Street and tore it down in 1898. Posten then hired Elmer F. Jacobs, a renowned Morgantown architect, to design this four-story brick building. Posten later sold the building to one of the wealthiest families in north-central West Virginia, that of John James Brown. Now known as the Brown Building or the Ream Building, it is currently home to Citizens Bank. (Morgantown Public Library.)

BUSINESS AND INDUSTRY

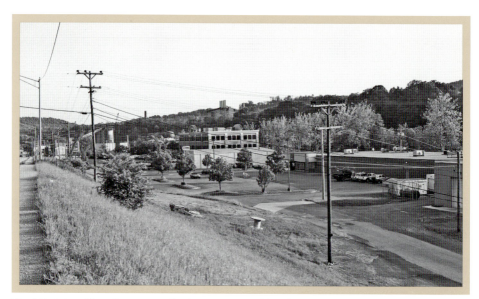

The Mississippi Glass Factory was built in 1902 and located on what is currently called Don Knotts Boulevard, named after actor and comedian Don Knotts, a Morgantown native. The factory produced wire glass, an industrial-strength glass with a mesh inlay to prevent shattering and breaking under extreme temperatures. The factory aided in Morgantown's industrial and economic growth. It closed in 1937 during the Great Depression. Currently, the site is occupied by Aldi's, a grocery chain store and numerous other businesses. (Rodney Pyles.)

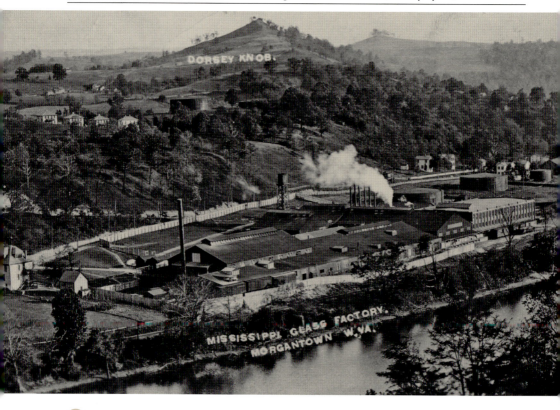

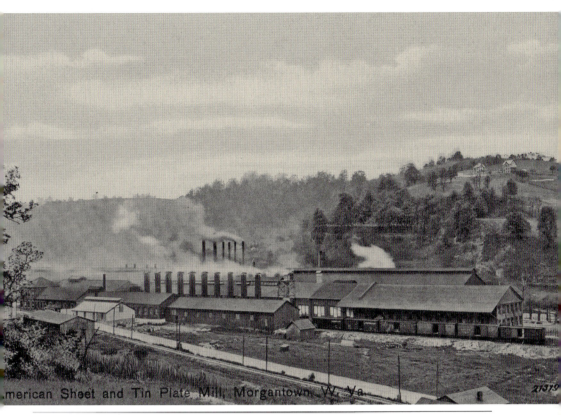

American Sheet and Tin Plate Mill opened in Sabraton in 1906. At the time, proprietor George Sturgiss presided over the largest industrial plant in Monongalia County. As was typical of the era, the mill attracted immigrant labor, and by 1921, many of the over 1,000 employees were born on foreign land. A model home constructed near the plant was used to teach immigrants to cook, clean, and care for their children as part of an Americanization program. Later, the factory became Sterling Faucet Company and occupied the old site for over 40 years. As of this writing, the vacant lot is under consideration to become the site of Morgantown's Goodwill Headquarters and a new Southern States store. (Rodney Pyles.)

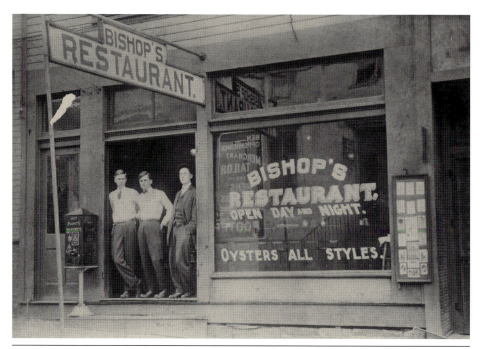

In 1908, Bishop's Restaurant, located at 230 High Street, advertised all-day service and oysters, which were packed in ice and shipped by rail to Morgantown from the Chesapeake Bay. Benjamin Oppenheimer's Merchant Taylor shop was also housed in the building located at the corner of High and Pleasant Streets. Later, Jamison & Jollife City Meat Market occupied the site. The street address has changed to 220 High Street, and the store is home to Arrow Gift Shoppe. (Morgantown Public Library.)

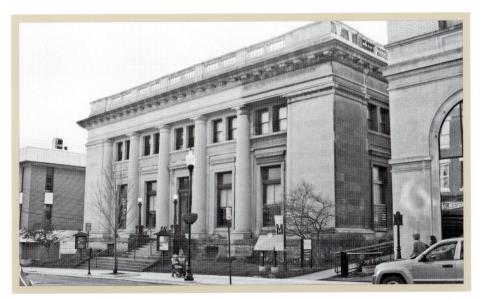

In 1914, construction started on the Morgantown Post Office at 107 High Street. Comprised of three stories and a basement, the Neoclassical building was designed by a US Treasury Department architect and was the first federal building in Morgantown. An addition was constructed at a cost of over $97,000 in 1931. In a great example of adaptive reuse, the building now houses the Monongalia Art Center. (Rodney Pyles.)

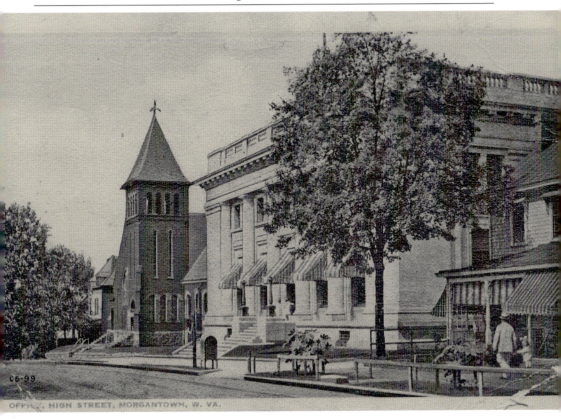

Business and Industry

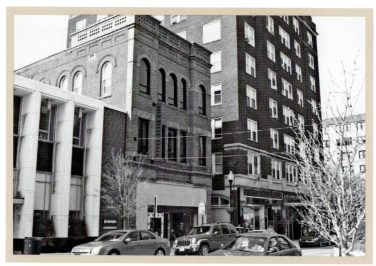

The steel beams of the eight-story Monongahela Building are shown under construction in 1921 at 235 High Street. At the time, the fireproof structure was the largest building in Morgantown, boasting over 200 office spaces. Originally home to the Monongahela Valley Bank, the building continues to provide office and retail space. Anchoring the ground floor is Pathfinder, a shop catering to outdoor enthusiasts. (Morgantown Public Library.)

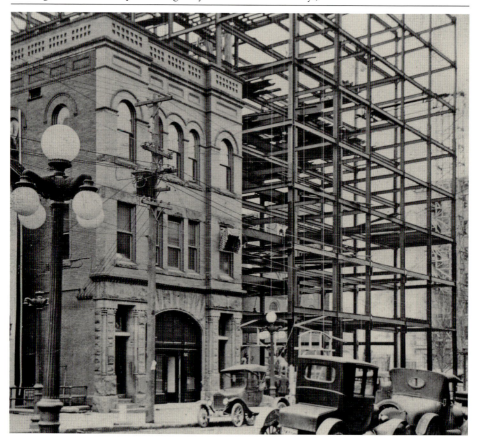

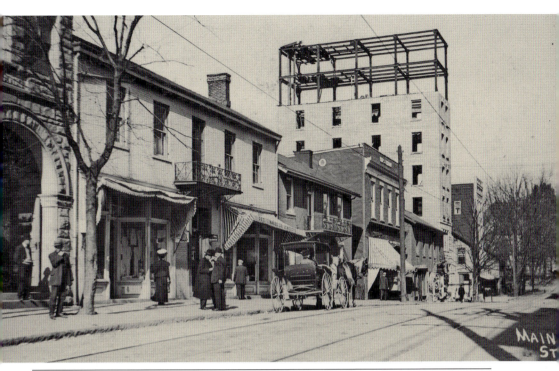

This is a 1920s postcard of what used to be known as Main Street but, in modern Morgantown, is now called High Street. During this time, Morgantown's growth continued to explode. The opening of the coal industry brought a wave of immigrants to the area. In 1920, Morgantown's population was 12,127, as opposed to 9,150 in 1910. Today, Morgantown has a permanent population of nearly 30,000 people and continues to attract a strong immigrant population migrating into the area for education and jobs. There are over 35 languages spoken in the area. Even though Morgantown has shifted the majority of its economic gain from the extractive industries to the medical and educational industries, coal and natural gas still play an important role in the economy and culture of the area. (Rodney Pyles.)

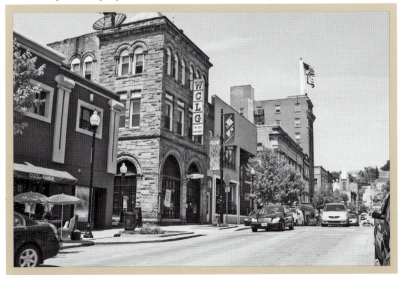

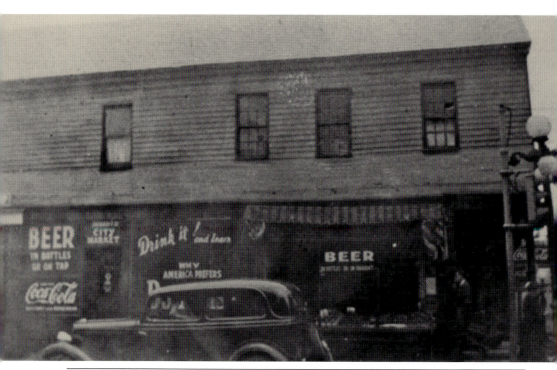

Built in 1790, the McCleery House was the first two-story residence in Morgantown. Located at the southwest corner of High and Pleasant Streets, when this picture was taken sometime in the 1920s, the building housed G.T. Federer Meats on the first floor and the Gibson Photo Studio upstairs. Today, Huntington Bank occupies the site, which is adjacent to the historic Warner Theater. (Morgantown Public Library.)

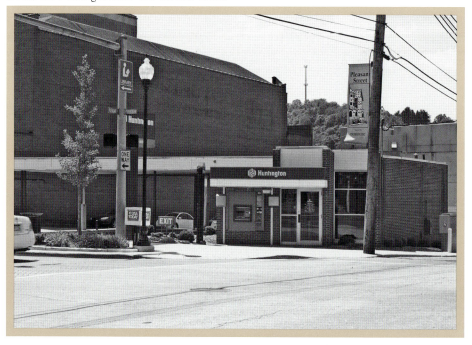

Here is the Brock-Reed-Wade Building in the early 1930s. Constructed between 1892 and 1895 at the northeast corner of High and Pleasant Streets, the building features an eclectic Victorian facade, mixing Romanesque, Italianate, and Queen Anne influences. The cast-iron tower was added in 1903. Longtime businesses that occupied the building included McVickers Pharmacy (1892–1980s) and Baker Hardware (1894–1996). It was also home to The Great Wall Chinese restaurant and, most recently, the architecture firm, the Mills Group. (Michael Mills.)

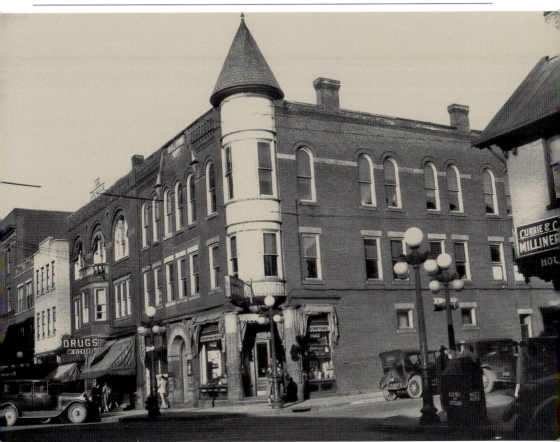

BUSINESS AND INDUSTRY

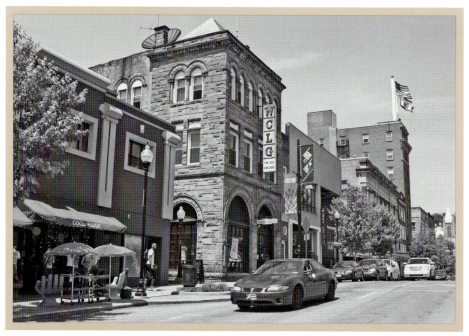

Here is a 1931 rush on the Second National Bank after it abruptly closed during the Great Depression. The Depression hit Monongalia County especially hard, resulting in a devastating 16.3 percent unemployment rate. The area coal fields were striking, and one of the largest local employers, American Sheet and Tin Plate Mill, shut down. Located at 341 High Street, the Second National Bank was built in 1894. Local architect Elmer Jacobs utilized a Romanesque Revival style in his design. Local radio station WCLG is among the building's current occupants. (Rodney Pyles.)

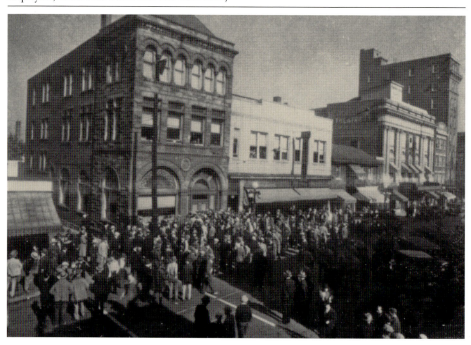

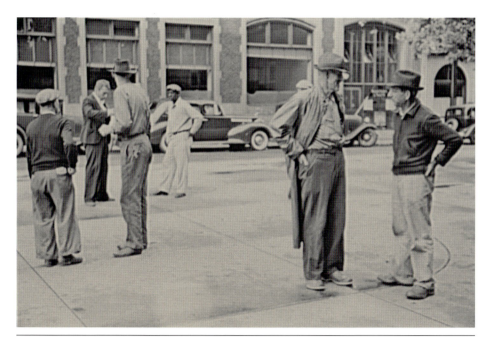

Works Progress Administration photographer Marion Post Wolcott captured the men hanging around courthouse square while waiting for work or a lucky break in 1933. The WPA was a New Deal program created by the administration of Franklin D. Roosevelt in an effort to employ millions of otherwise unemployed workers on public work projects of all types, including building much of the infrastructure still in use at nearby Coopers Rock State Park. (Library of Congress.)

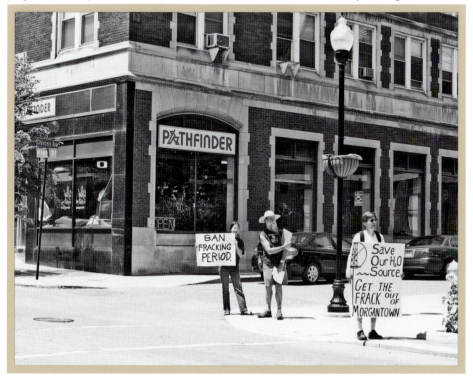

BUSINESS AND INDUSTRY

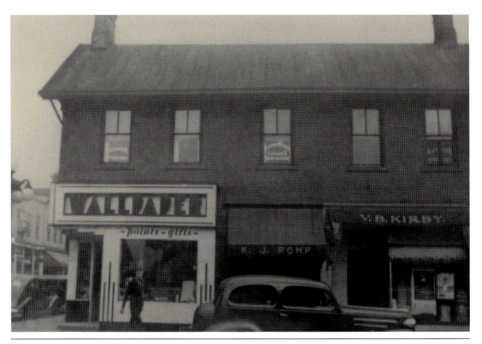

Most likely unaware of the building's history, a soldier walks past 170 High Street at some point during the World War II era. One of Morgantown's earliest surviving structures, the Old Neville House was built in 1823 in the Federal style for Joshua Neville, a prominent road builder. Although altered considerably through the years, the first floor has remained a storefront since 1885, inhabited by a number of different businesses, including the Keystone Stores Corporation, Buseman and Kendell Wallpaper and Paint Store, Semler's News Stand, and City Pharmacy. It is now home to The Great Wall restaurant. (Morgantown Public library.)

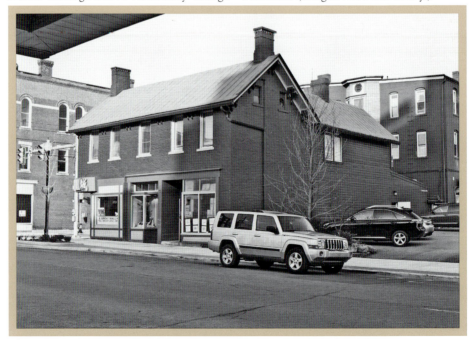

St. Vincent Pallotti Hospital is shown in the mid-20th century. The hospital had a history of repeated relocations and name changes. Originating in Westover in 1900, the facility later moved to High Street, where it was known as City Hospital. Around 1928, the hospital moved again, this time to Willey Street. In 1943, it was renamed Heiskell Memorial Hospital. In 1950, the Catholic Pallottine Missionary Sisters bought it for $300,000 from Dr. Edgar Frank Heiskell and renamed it for the final time. The hospital ceased operations in 1972 when it was bought by Monongalia General Hospital. Unity Manor Apartments now occupy the building. (Rodney Pyles.)

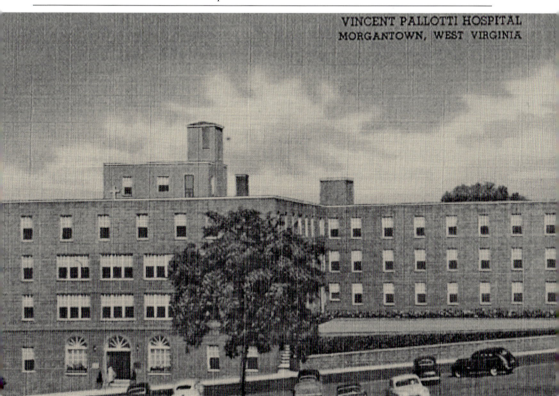

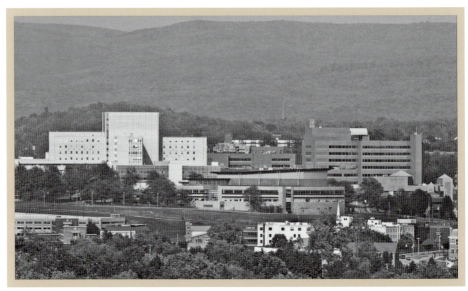

In 1957, construction was started on the West Virginia University Medical Center. At the time, it was one the largest building projects ever initiated in Monongalia County. Completed in 1960, it was over 12 stories tall and had over 2,000 rooms. Today, West Virginia University Hospital continues to grow. The original building, constructed in 1960, is now the Health Sciences Building, and in 1988, Ruby Memorial Hospital was constructed next to the old hospital. In 1998, the hospital bought the neighboring Chestnut Ridge Hospital, a psychiatric facility, and built the Rosenbaum Family House. The Ronald McDonald House also calls the location home. According to the 2009 "West Virginia University Healthcare" annual report, the medical facilities and the school of medicine together contributed $2.2 billion to the state's economy. Plans are in the works to renovate and upgrade the facilities to ensure the strong economic and public health legacy of the institution is passed on to future generations. Mylan Puskar Stadium, home of the West Virginia University Mountaineers, is also located there. (Rodney Pyles.)

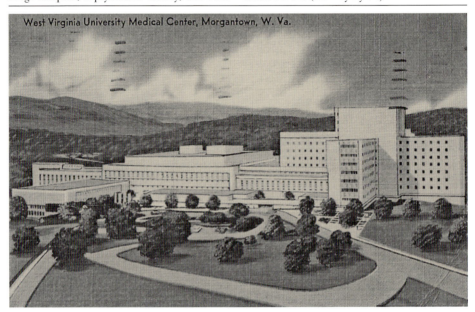

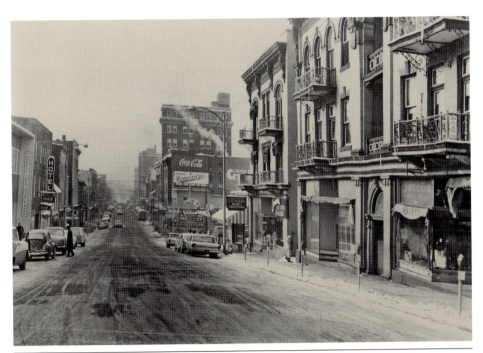

This scene shows the corner of High and Willey Streets as one would encounter it during the late 1950s. On the right is the I.C. White apartment building. Built in 1911 in Italianate style, it is considered the first modern apartment building in Morgantown. Today, Casa Di' Amici, an Italian food and pizza restaurant, is located in the I.C. White building, as well as Figleaf, a women's clothing boutique. (Rodney Pyles.)

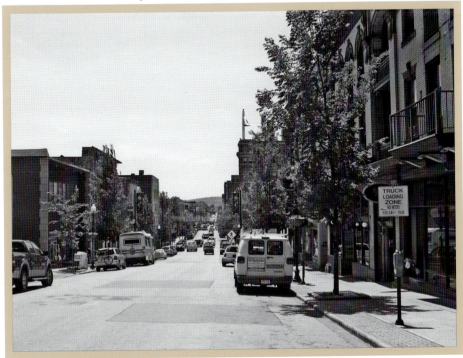

Business and Industry

49

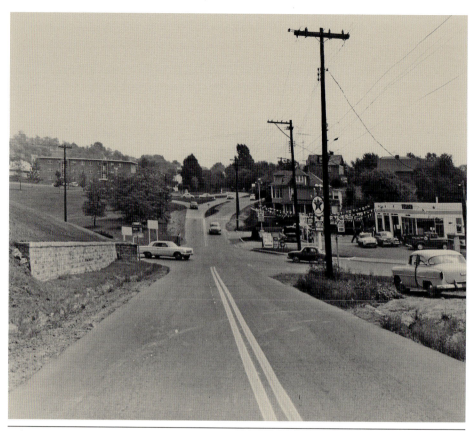

Here is the corner of Patteson Drive and University Avenue where Suncrest meets Evansdale in the early 1960s. The area has grown to include several businesses and restaurants, as well as the new West Virginia University Alumni Center. (Bill Rumble.)

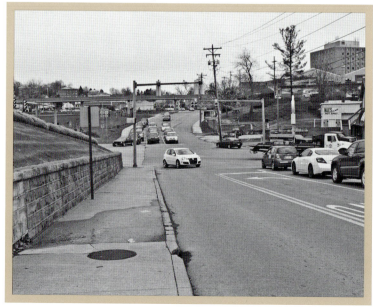

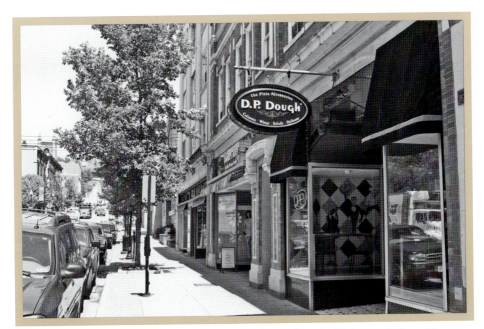

Looking south, this photograph shows downtown Morgantown High Street in the mid-1960s. The Bartimoccia family operated High Street Market at the corner of High and Fayette Streets in the late 1960s. The Bartimoccias bought the market from the Titus family in 1965. It is now a Subway. Also visible, J. Biafora and Sons Menswear, The Fashionable Shoe Story, and Finn's are now occupied, respectively, by Tanners Alley Leather Shop, pizza shop D.P. Dough, and Coni & Franc's, a ladies' fashion and wedding boutique. (Morgantown Public Library.)

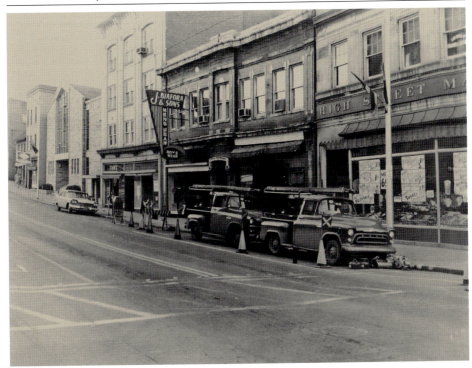

Business and Industry

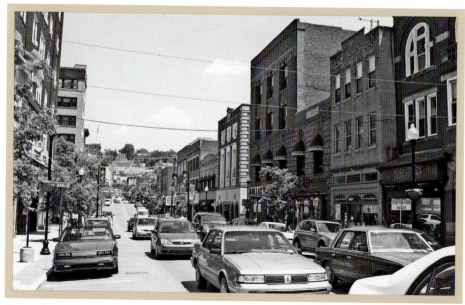

Yet another picture of downtown Morgantown in the 1960s shows, on the right-hand side, the Batlas Building on High Street. It was built by John and Theodore Batlas in 1923 and housed their business, the Boston Confectionary. In 1937, it became the home of G.C. Murphy Company. Later, it was an A&P grocery store. Today, the Batlas Building houses apartments and a Dollar General store. (Rodney Pyles.)

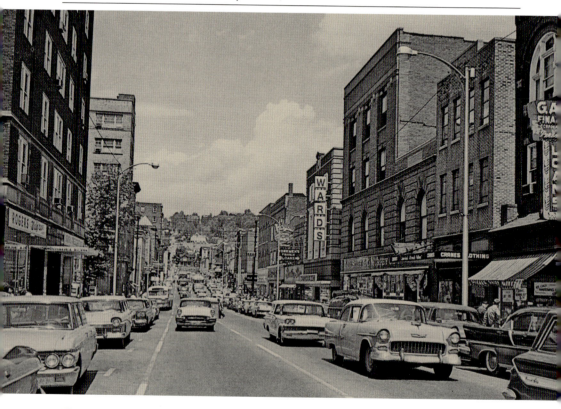

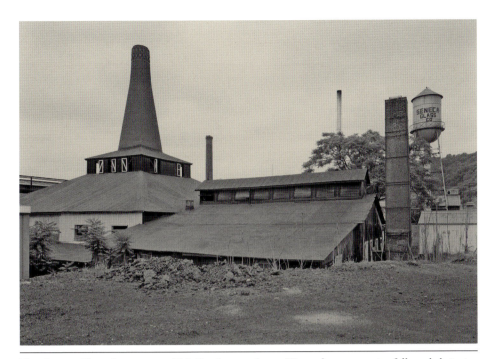

The Seneca Glass Company at 709 Beechurst Avenue was built between 1896 and 1897. The company, originally called Fostoria Glass, relocated to Morgantown from Fostoria, Ohio, because the Morgantown area offered an abundance of natural gas, a free building site, and easy transport to other markets, thanks to infrastructure improvements like the locks and dams on the Monongahela River and the arrival of the Baltimore & Ohio Railroad. Morgantown also offered the company a $20,000 subsidiary to relocate, thus, Seneca Glass Company was born. Nine other companies followed, bringing with them old-world techniques that produced some of the finest glass in the world. The Seneca Glass factory permanently closed in 1983. The structure is listed on both the Historic American Engineering Records Survey and the National Register of Historic Places and has been the subject of a documentary film. Today, it is a well-preserved, rehabbed complex of offices and retail stores known as the Seneca Center. (Library of Congress.)

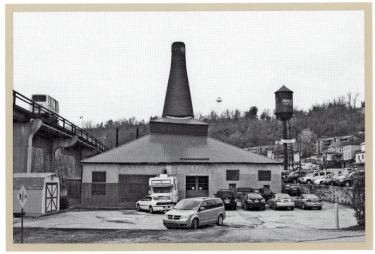

BUSINESS AND INDUSTRY

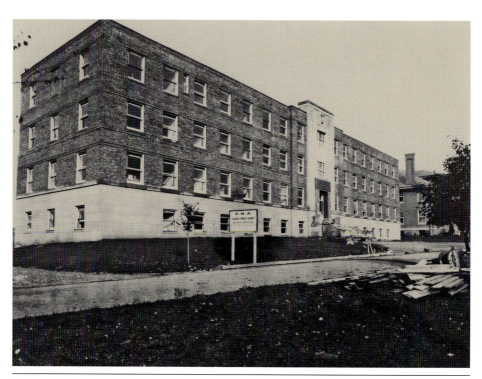

Monongalia County Hospital was established in 1922 on Van Voorhis Road. In 1940, it moved into Monongalia County Poorhouse, and the name was changed to Monongalia General Hospital. In 1972, the hospital merged with the St. Pallotti Hospital. The current building was completed in 1977 and is located on J.D. Anderson Drive in Morgantown, West Virginia. In 2008, the hospital underwent major renovations and expansion. The new Hazel Ruby McQuain Tower provides all private inpatient rooms, a women's imaging center, a large emergency department, an expanded imaging department, and a state-of-the-art intensive care unit. Today, Mon General is an all-private, inpatient facility. (Mon General Hospital.)

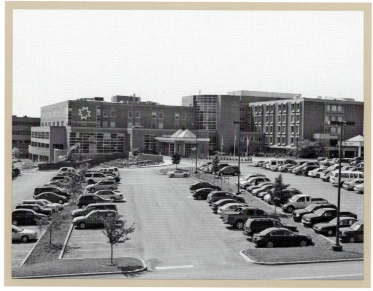

CHAPTER 3

LIFE IN AND AROUND MORGANTOWN

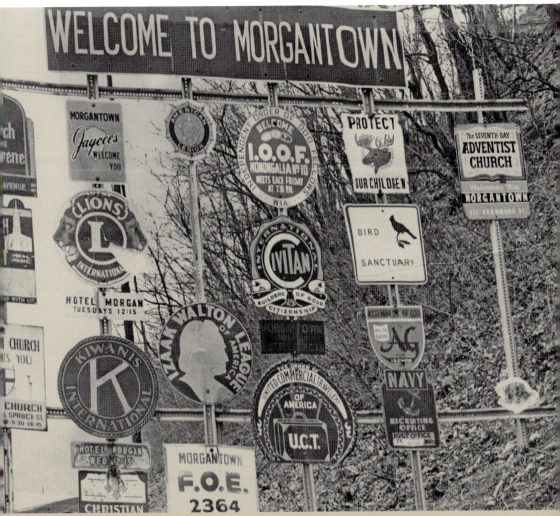

Visitors entering Morgantown in the 1960s would encounter this collection of signs, alerting them to the many civic, fraternal, and service organizations that called the city home. (Bill Rumble.)

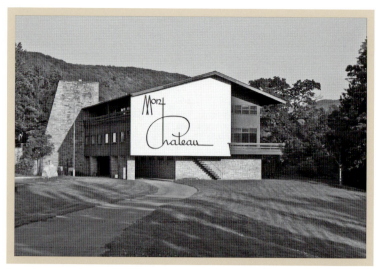

Built in 1894, the original Mont Chateau lodge sat a short distance uphill from the Cheat River, near what is now the uppermost portion of Cheat Lake. Carriages would bring guests from Morgantown for their stay at the lodge. In 1920, it was purchased by a private club out of Pittsburgh but continued as a vacation getaway. In 1955, the state of West Virginia bought the 42-acre resort and turned it into a state park. The lodge burned down in 1956, and a new lodge was built at a cost of $400,000. It remained a state park until 1977, when the West Virginia Geological and Economic Survey purchased it. Today, the organization still occupies the lodge. Only 13 of the original 42 acres remain with the property. (Morgantown Public Library.)

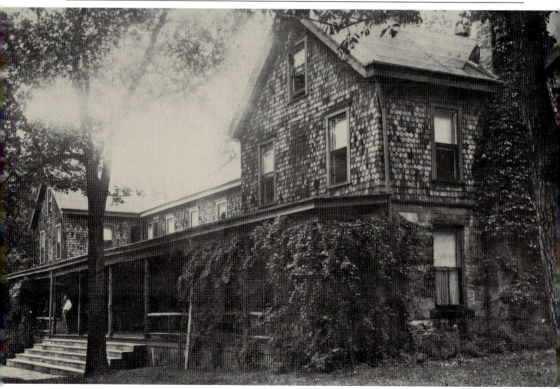

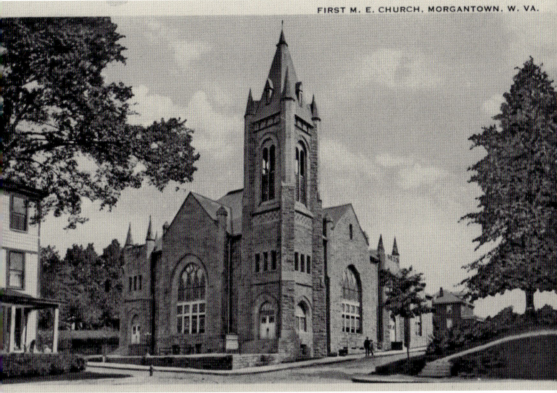

The Wesley Methodist Church at the corner of High and Willey Streets was constructed in 1903 in English Gothic style. On New Year's Day 1946, a fire destroyed the large stained-glass window. An earlier congregation, established in 1850, existed on Pleasant Street. (Rodney Pyles.)

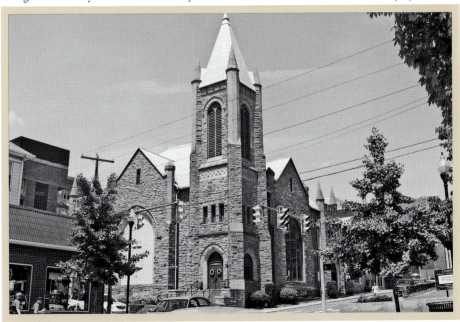

LIFE IN AND AROUND MORGANTOWN

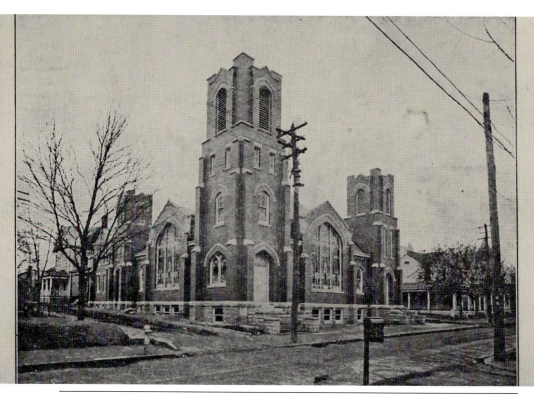

The Spruce Street Methodist Church at 386 Spruce Street was completed in 1908 at a cost of over $40,000. In 1939, a merger occurred between the Methodist Protestant and Methodist Episcopal churches, and the United Methodist Church was born. In 1953, a new addition included a Sunday school and recreation room. (Rodney Pyles.)

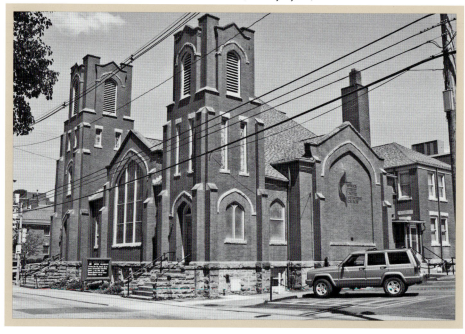

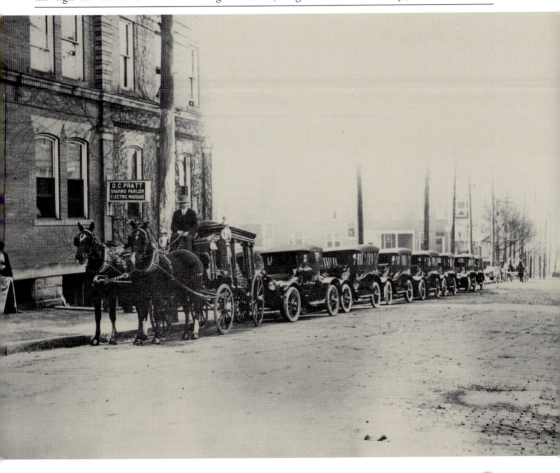

A funeral procession travels along Walnut Street near the Brown Building around 1910. Note the sign for the "D.C. Pratt Shaving Parlor Electric Massage." As mentioned earlier, the Brown Building is now home to Citizens Bank. (Morgantown Public Library.)

Life in and around Morgantown

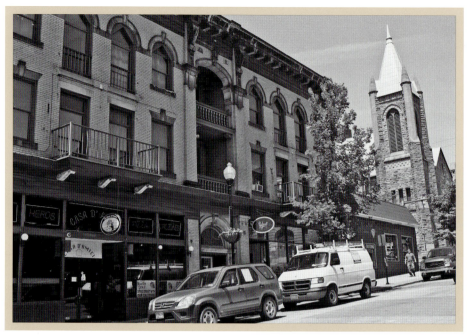

This 1912 parade route leads down High Street past the I.C. White apartment building. Also seen in the picture is Wesley Methodist Church. (Morgantown Public Library.)

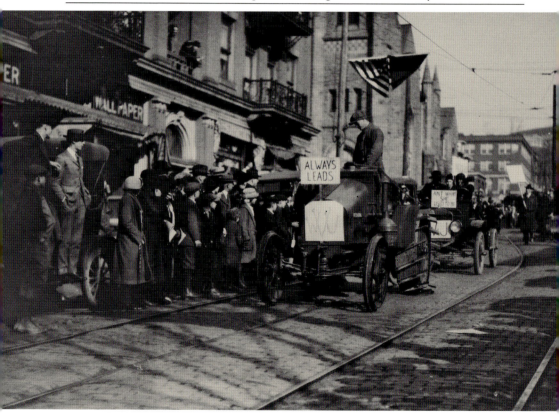

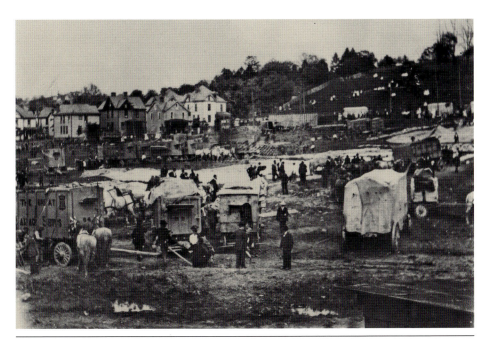

This 1915 picture is of the Great Palace Show circus setting up the big top between the railroad yard and, what is today, Don Knotts Boulevard. In the present-day image, one can see the Baltimore & Ohio Railroad terminal and riverfront. Morgantown was not a railroad town and had no real railroad yard. The performers would have likely gotten off at the depot and worked their way toward the Wharf District. By best approximations, the circus was erected where Waterfront Jeep sits. (Morgantown Public Library.)

LIFE IN AND AROUND MORGANTOWN

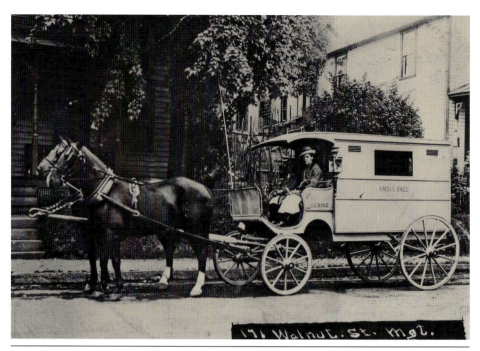

Here is a horse-drawn ambulance parked at 171 Walnut Street sometime between 1910 and 1920. Considering Dering Funeral Home was next door at 177 Walnut Street, one must wonder if the ambulance's occupant was beyond medical attention. The structure is gone, and in its place, a parking lot has been built between the Dering Building and the Hayes Building. The Dering Building, designed by Elmer Jacobs, was constructed in 1896 for Fred Dering. Of Romanesque Revival–style, the building was originally used as a harness shop. In 1910, Dering converted the it into a funeral home. The Hayes Building is now home to the law firm of Wilson, Frame, and Metheny. (Morgantown Public Library.)

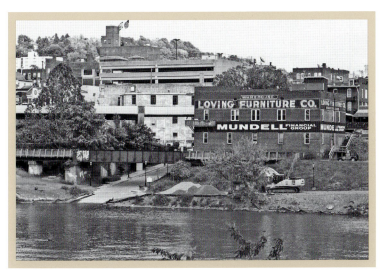

A crowd gathered around the Baltimore & Ohio Railroad trestle to observe the damage caused by river ice after a powerful winter storm around 1920. Today, the trestle is enjoyed by the public as a part of the Mon River Trail Conservatory. The old Chaplin, Warman & Rightmire Lumber & Millwork Building (1906) can be seen. The building went on to become the home of Loving Furniture Company and, most recently, Mundell Financial Group. (Morgantown Public Library.)

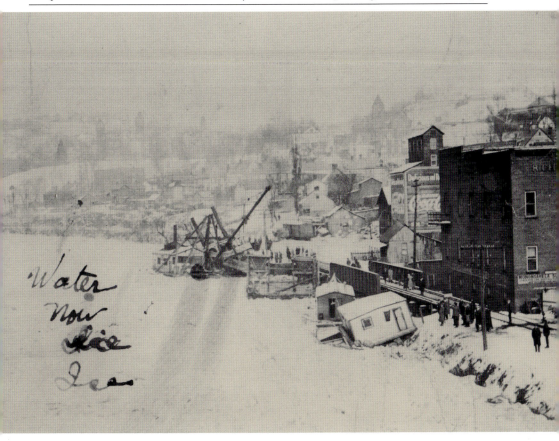

LIFE IN AND AROUND MORGANTOWN 63

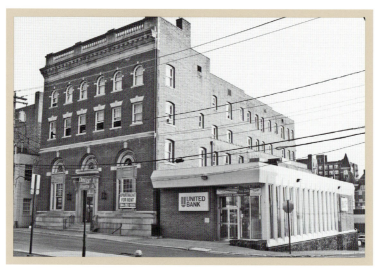

These are members of the Monongalia Woman Temperance Union in an undated photograph that appears to be from the 19th or early-20th century. The Monongalia Christian Temperance Movement began in Morgantown with 19 members in 1884. Elizabeth Moore, founder of the Woodburn Female Seminary and Morgantown Seminary, was elected president. Between 1922 and 1924, a Neoclassical building was constructed at 160 Fayette Street to house the movement and was the largest WCTU (Women's Christian Temperance Union) structure in the state, containing both an auditorium and gymnasium. Although numerous commercial entities have occupied the building, the structure itself has remained virtually unchanged and stands as a reminder of the role of women in pivotal moments in the history of not only West Virginia but also the United States. In 1985, it was added to the National Register of Historic Places. (Morgantown Public Library.)

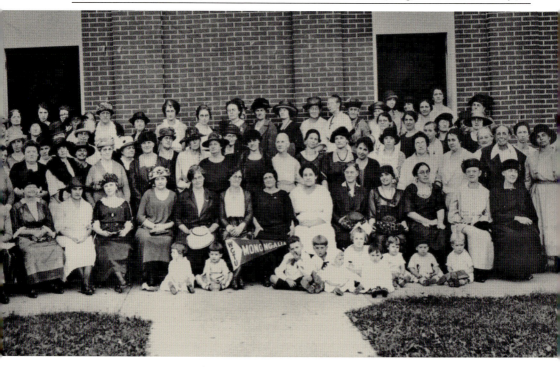

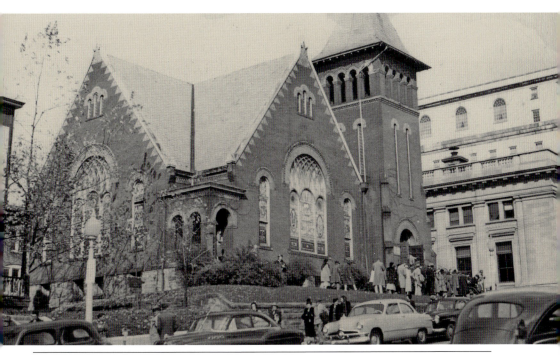

The Presbyterian church, which stood at the corner of High and Kirk Streets, was built in 1910. Decades later, it was razed, and the empty lot was used as a car dealership. In 1973, the city constructed the Morgantown Federal Building and Post Office, which was a replacement for the old Morgantown post office (1915) seen next to the church in the photograph. The 1973 post office building is now the Harley O. Staggers Federal Building, as a new post office has been constructed a short distance down and across the street. Since 1977, the 1915 post office building has been the home of the Monongalia Arts Center. Also in the picture is Hotel Morgan, which was completed in 1925. Named after the founder of Morgantown, Col. Zackquill Morgan, the Hotel Morgan is now owned and operated by Clarion Hotels. As of this writing, the Harley O. Staggers Building is currently being assessed by the Monongalia County Commission to determine whether or not it can be rehabilitated for future county use. (Morgantown Public Library.)

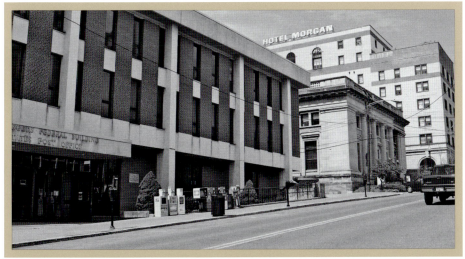

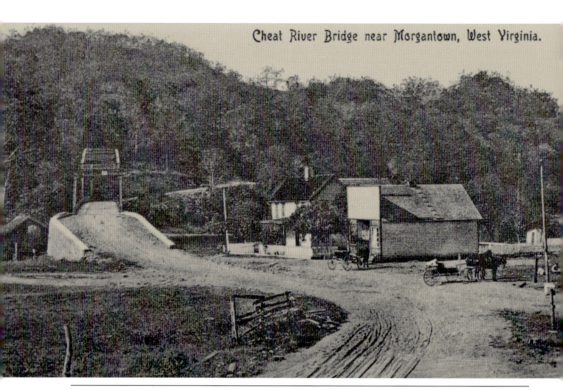

The Old Cheat River Bridge was constructed in 1922. The four-span steel bridge crosses Cheat Lake near what used to be Ice's Ferry. Cheat Lake and the surrounding area of the same name are considered a suburb of Morgantown, and the lake itself is a heavily used recreational area where people boat, swim, and play golf, among other pastimes. The bridge was recently taken out of service and is being sold for scrap metal. A new bridge will replace it. (Morgantown Public Library.)

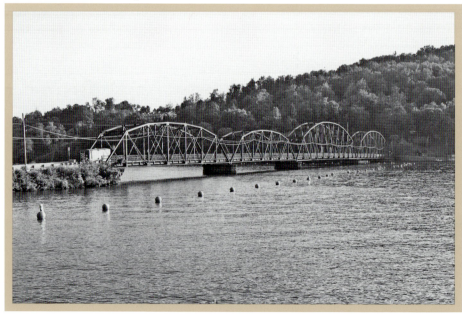

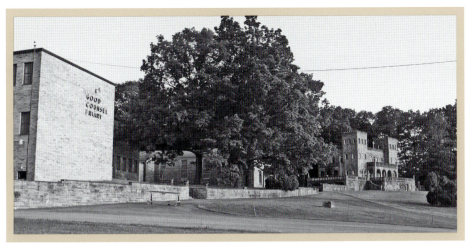

Construction began on Thoney Pietro Castle in 1928 and was finished five years later at a cost of over $200,000. To keep things in perspective, the legendary Frank Lloyd Wright–designed Fallingwater was built at roughly the same time at a mere cost of $55,000. Pietro is a legend in the Morgantown community. He was responsible for erecting many structures, as well as building sidewalks, walls, and brick streets. In 1900, he held the world record for bricklaying, averaging 136 bricks per minute. In 1949, the Pietro family donated the property to the Franciscan Friars of the Immaculate Conception Province out of New York City to start a missionary. The Good Council Friary used the castle for over 30 years until closing its doors in 2008. The property is currently for sale for $2.5 million and is a hot topic of debate for area residents. Many want it to be preserved and adaptively reused, while others wish to demolish it and develop the land. (Rodney Pyles.)

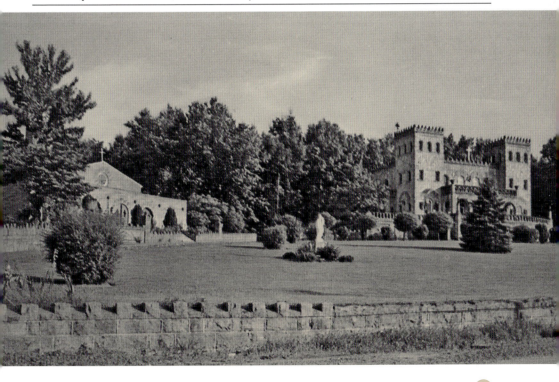

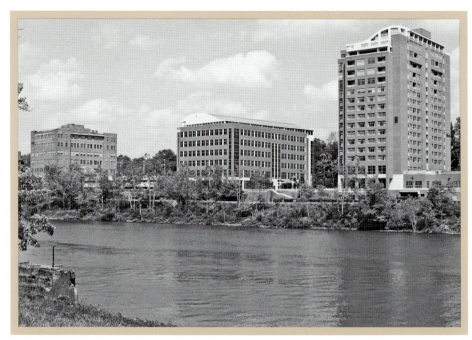

This is a postcard of children swimming at the old locks. The back of the card notes that the boys liked to swim in the deep end and tease the girls. New locks were constructed between 1948 and 1950. A small stone structure from the old lock and dam is still visible. Today, the river is used mainly for fishing and boating. (Rodney Pyles.)

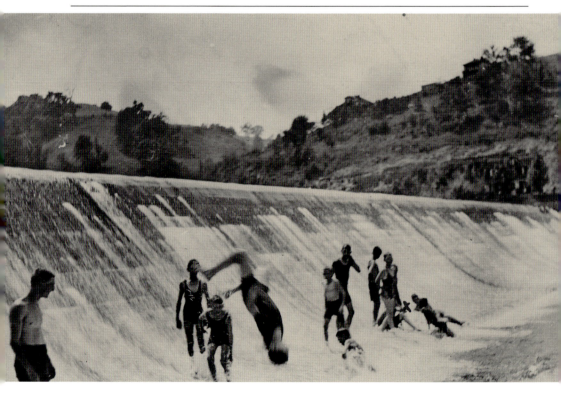

In addition to its contributions to Morgantown's commercial and industrial life, the Mon River has long provided a source of recreation for residents and visitors alike. This is a picture of a 1950s boat race on the Monongahela River during Labor Day celebrations. The tradition of recreation on the river continues, as the present-day photograph can attest. Among other activities, the Mon is now home to swimming segments of many triathlons and the Monongahela Rowing Association. (Morgantown Public Library.)

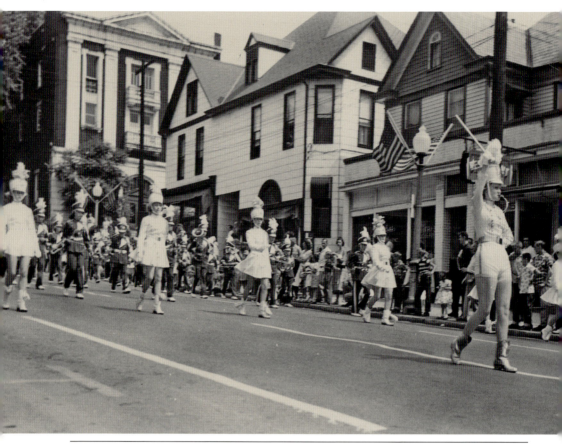

Parades have always been a popular form of entertainment in Morgantown. This 1950s-era parade is at the corner of High and Willey Streets. The Masonic Lodge, which was built in 1916, is currently used as an apartment building. The lot on the corner was home to many businesses through the years, including Ramsey's Meat Market, Burger Boy Food-O-Rama, Border Burger, and Burger Chef. Today, it is home to BB&T Bank. (Morgantown Public Library.)

Yet another parade, this time from the 1960s, passes in front of the old Baptist church and Finn's Dress Shop on High Street. The First Baptist Church was established in 1842 on Bumbo Lane, which was eventually changed to, and remains, Fayette Street. In 1897, the church built a new structure at 432 High Street and has been at that address ever since. In 1951, the church added a new educational building in the back and, in 1956, added a stone veneer to the front of the building. Finn's, at 422 High Street, was located in the Standish Apartment Building. Currently, it houses the upscale dress shop, Coni and Franc's, established in 1982. (Rodney Pyles.)

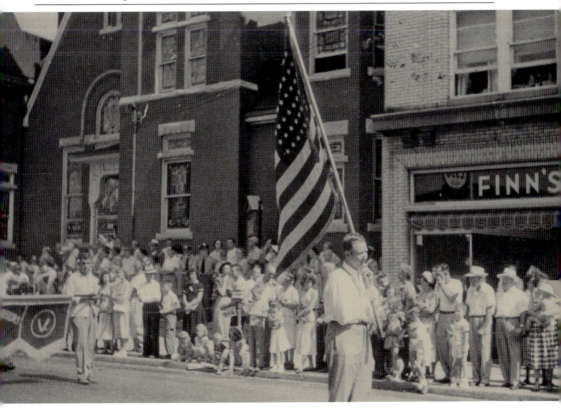

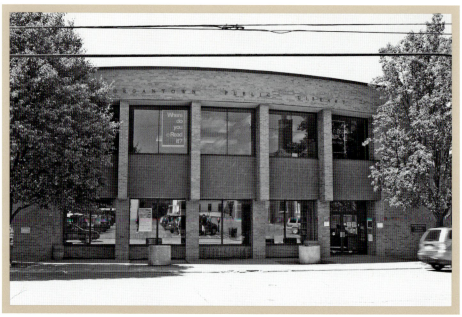

The Morgantown Public Library, designed by local architect Robert Bennett, was built between 1963 and 1964 at a cost of over $300,000. Morgantown's commitment to a free public library dates back to the days of the Monongahela Academy, which was home to the area's first library in the 19th century. In 1926, the Morgantown Women's Club formed a library committee and, subsequently, the makeshift Waitman Barb Library at 356 Spruce Street. Shortly thereafter, in 1927, the library moved to municipal hall where it remained until relocating to its current home in 1964, at which point it was renamed the Morgantown Public Library. (Morgantown Public Library.)

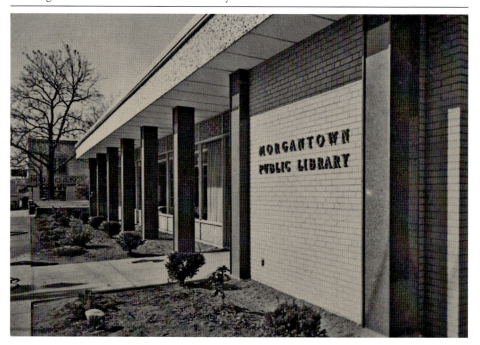

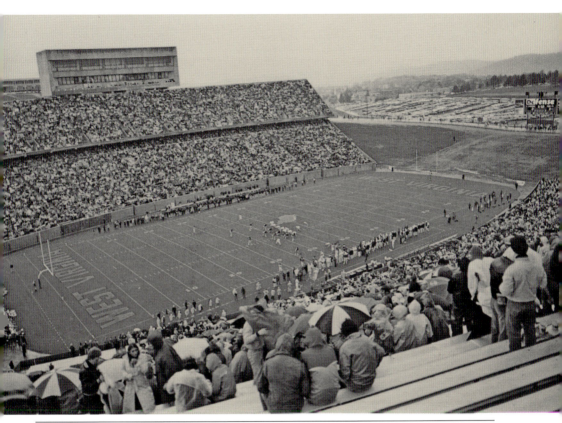

The Mountaineers, West Virginia University's football team, played their first game in 1891 on the drill and athletic field, which is where the Mountainlair garage and plaza stand. In 1924, the Old Stadium was constructed and hosted home football games until 1979. In 1980, construction was completed on the new Mountaineer Field on the site of the old Morgantown Golf Course and Country Club. (Above, Rodney Pyles; below, Julie Foster.)

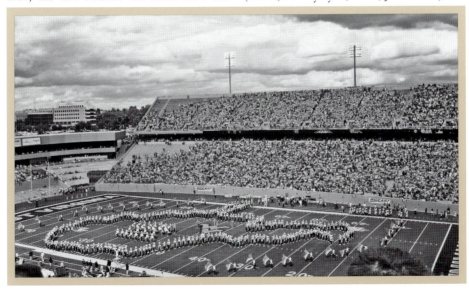

LIFE IN AND AROUND MORGANTOWN

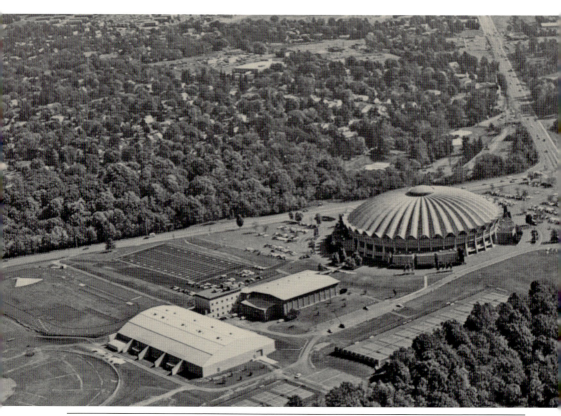

Construction wrapped up on the West Virginia University Coliseum in 1970, which replaced the 6,000-seat field house on Beechurst Avenue. The first event held in the new 14,000-seat multipurpose arena was a concert by the rock group Grand Funk Railroad. Located on the Evansdale campus, the coliseum cost over $10 million to build and is home to West Virginia University's men's and women's basketball, gymnastics, and volleyball teams today. The coliseum underwent renovations in 2004 and 2008 and, in addition to sporting events and concerts, is also used for graduation ceremonies. (Michael Mills.)

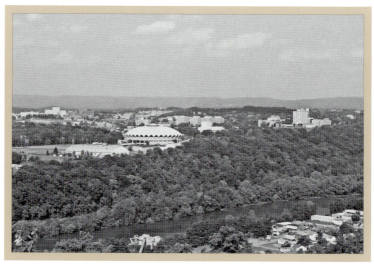

CHAPTER 4

EDUCATION

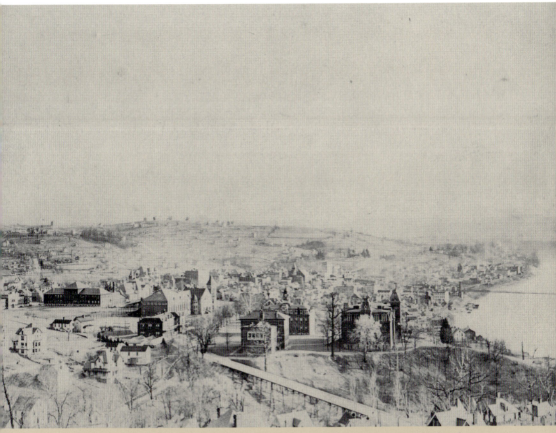

This old photograph gives the viewer not only a sense of the entirety of West Virginia University's campus prior to the 1924 construction of Mountaineer Field but also captures much of Morgantown proper during the period. Visible in the image, among other landmarks, are the Falling Run footbridge, Mechanical Hall, Commencement Hall, Woodburn Circle, and the Agricultural Experiment Station. (Rodney Pyles.)

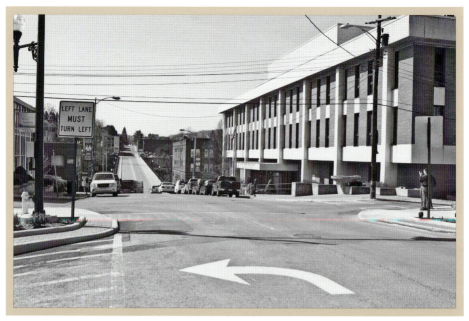

Morgantown Female Seminary was built in 1870. Located on the corner of High and Foundry Streets, it was the last female seminary in Morgantown. It was owned and operated by Elizabeth Moore, who had previously overseen the Woodburn Female Seminary, predecessor to Woodburn Hall. At the time, coeducation was very controversial. The seminary burned down in 1889, and a month later, coeducation was passed by the state legislature, giving the female population access to West Virginia University. (Rodney Pyles.)

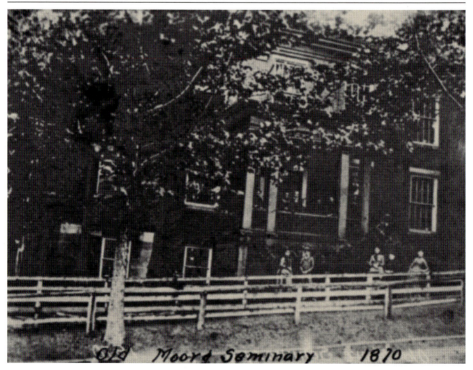

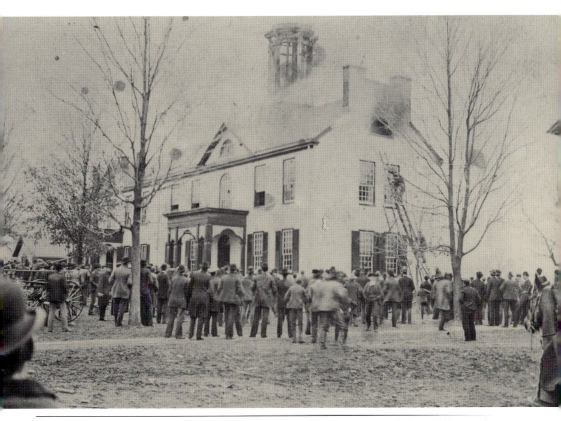

Students and spectators watch the Monongahela Academy burn down on January 11, 1897. Monongahela Academy was built in 1829 at the corner of Spruce and North Boundary (now Walnut) Streets and was a private subscription school. In 1867, the academy became part of the Agricultural College of West Virginia, and a year later, it was sold to the newly formed Monongalia County Board of Education and reopened as a grade school. Central Grade School was built to replace Monongahela Academy Building after it burned down in 1897. Today, the spot is the site of the public safety building and parking garage. (Morgantown Public Library.)

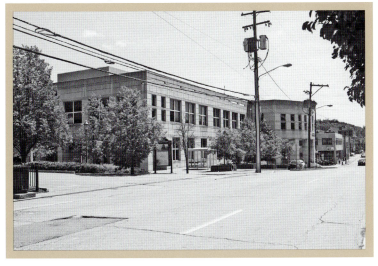

EDUCATION

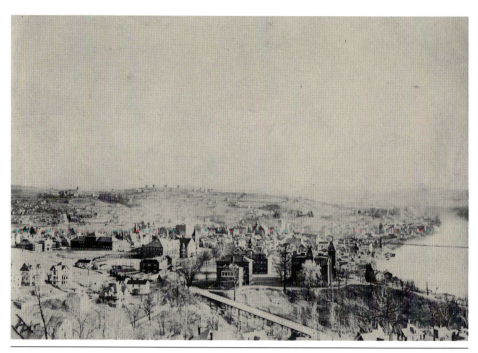

In 1894, a pedestrian bridge was constructed over Falling Run, connecting Sunnyside to Morgantown proper. In 2005, a new footbridge was constructed by March Westin Company at a cost of over $1.6 million. The pedestrian bridge connects the business and economics building to Oglebay Hall in an effort to reduce foot traffic crossing University Avenue. (Michael Mills.)

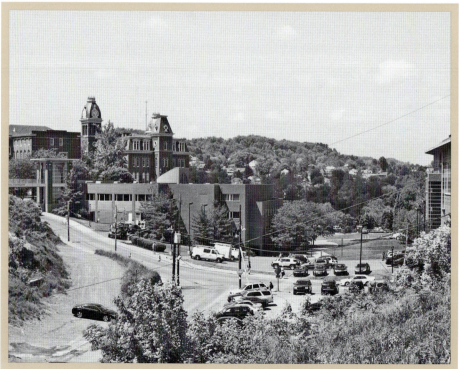

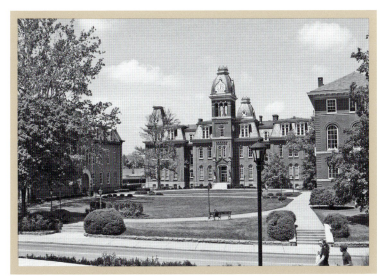

The three original buildings of West Virginia University that grace Woodburn Circle are clearly visible in this c. 1900 photograph. From left to right are Martin Hall, built in 1870 (the oldest building on campus); Woodburn Hall (the central structure) was built in 1876 and originally called University Hall, additions were made to Woodburn in 1900 and 1911; and Chitwood Hall (originally called Science Hall) was built in 1893. All three structures have been restored and are listed in the National Register of Historic Places. (Morgantown Public Library.)

EDUCATION

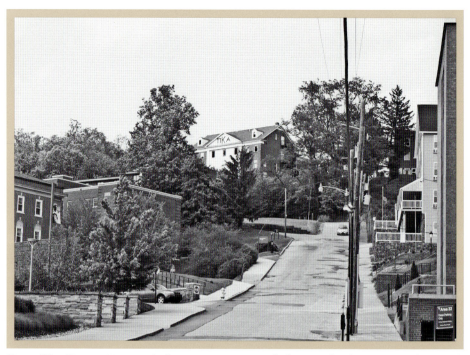

Here is West Virginia University's observatory in the early-20th century. On November 3, 1919, in a fit of irrational exuberance, students celebrated a crushing football win over Princeton University (25-0) by burning the observatory to the ground. Today, the abandoned Pi Kappa Alpha fraternity occupies the site. Hodges Hall houses the current observatory. (Morgantown Public Library.)

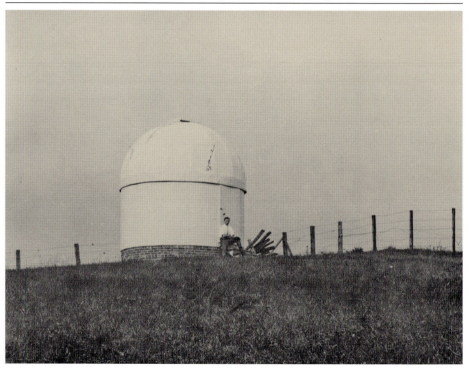

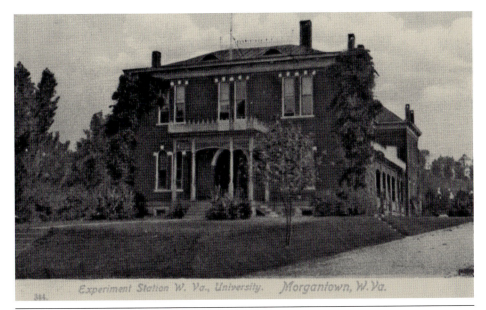

In 1889, West Virginia University moved the Agricultural Experiment Station into the recently renovated old armory building that was expanded in 1893. The Agricultural and Forestry Experiment program is the oldest of its kind in the state and, owing to the terms of the Morrill Act, has been a part of West Virginia University's history from its beginning. Renamed the Davis College of Agriculture, Forestry, and Consumer Sciences, the program continues to contribute to research in its various disciplines and also possesses one of the largest fungi collections in the world. Today's West Virginia University student will recognize the site as Oglebay Plaza, so named for its location in front of Oglebay Hall. The plaza serves as a memorial for those lost on the battleship USS *West Virginia* at Pearl Harbor and for West Virginia University students who died during military service. The mast from battleship USS *West Virginia* and the bell from the armored cruiser USS *West Virginia* are both preserved here. (Morgantown Public Library.)

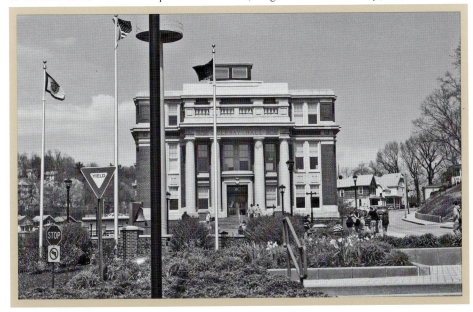

Education

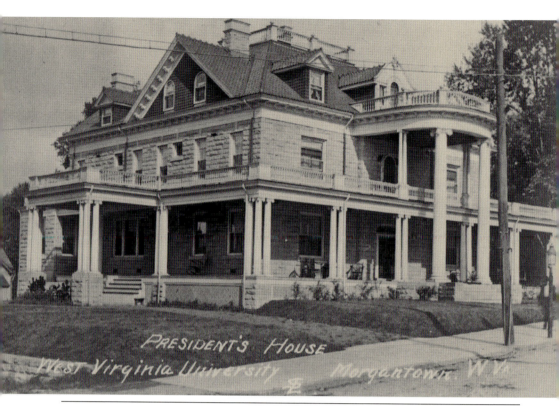

Architect J. Charles Fulton designed the Neoclassical Purinton House. Constructed in 1904 as a home for West Virginia University president Daniel B. Purinton, the structure has a controversial background. Purinton was denied public funding for the construction of the house and had to use private resources. Purinton used student fees to finish the construction, which infuriated many in the community. In 1911, President Taft gave a speech in front of Purinton House. Since 1967, the university's presidents have occupied Blaney House on Riverview Drive near Evansdale campus, while Purinton House is now home to West Virginia University Child Development and Family Support Services. (Morgantown Public Library.)

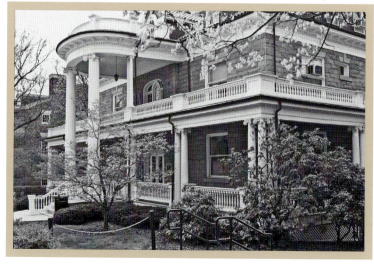

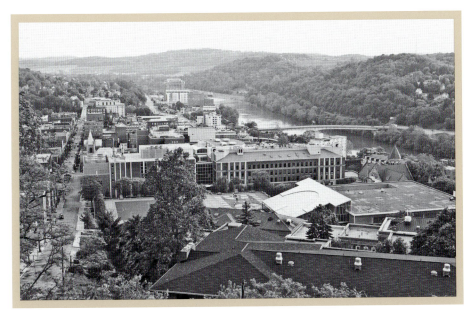

This postcard gives a bird's-eye view of West Virginia University and downtown Morgantown from Observatory Hill. The site still affords one of the best unobstructed views of the city and shows the progress and expansion of West Virginia University's campus and downtown Morgantown. (Rodney Pyles.)

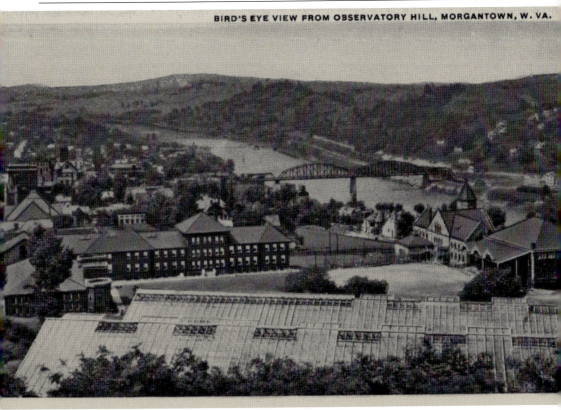

Education 83

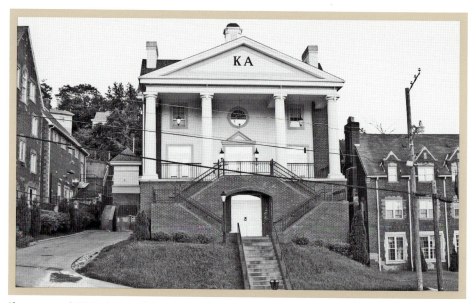

Shown around 1912, these students are members of Kappa Alpha fraternity. The Pi Chapter of Kappa Alpha started at West Virginia University in 1904, and its house was near the river on Walnut Street. In the late 1960s, a new house was constructed on top of Observatory Hill. Today, that house is abandoned, and the fraternity has a new building at 650 North Spruce Street. (Rodney Pyles.)

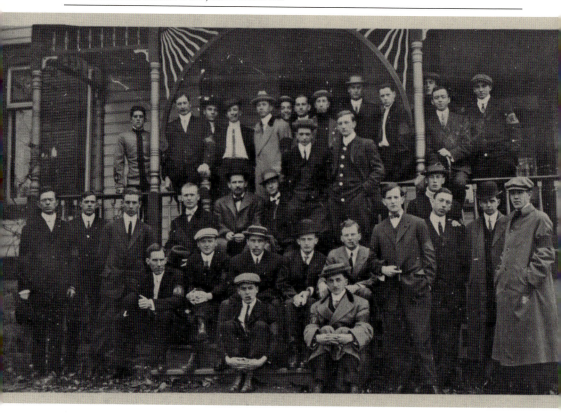

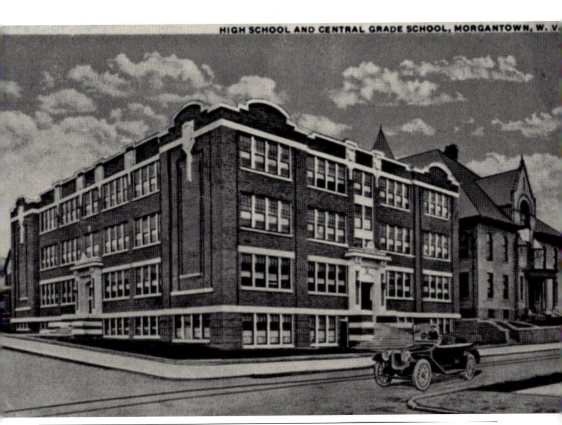

The old Morgantown High School and Central Grade School sat side by side. Central Grade School was originally the high school and was constructed in 1899 after a fire burned down the Monongahela Academy, which was located on the same site. When a new high school was built next door in 1915, the older building became Central Grade School. In 1927, yet another Morgantown High School was constructed, this time in South Park. Today, the public safety building and a parking garage occupy the space. (Rodney Pyles.)

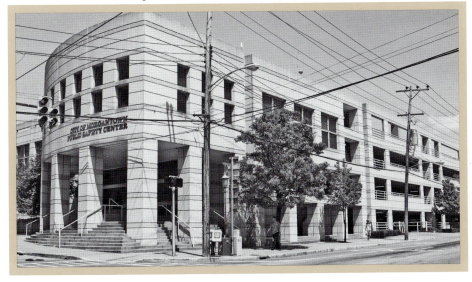

Education

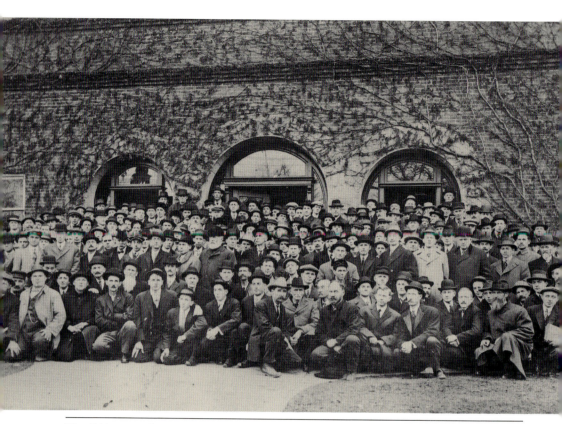

This 1918 picture shows a group of West Virginia University students in front of Commencement Hall. Built in 1892, Commencement Hall was utilized not only by West Virginia University but also by the entire community, who frequently came for graduation ceremonies, plays, concerts, and lectures. West Virginia University has a deep tradition of staying connected to Morgantown and creating opportunities for nonstudents to enjoy events on campus. The building was razed in 1965 in preparation for construction of Mountainlair, "the hub of student life" at West Virginia University. (Morgantown Public Library.)

Stalnaker Hall, or Women's Hall, is a dormitory constructed in 1920 in the Neoclassical style. It was the first residence hall at West Virginia University and housed only female students. Named after Elizabeth Stalnaker, a well-respected and much-loved professor of philosophy and psychology at the university, it underwent massive renovation in 1993 and remains a residence hall, albeit coed. The US Department of the Interior has designated Stalnaker Hall a historic building and placed it on the National Register of Historic Places. (Morgantown Public Library.)

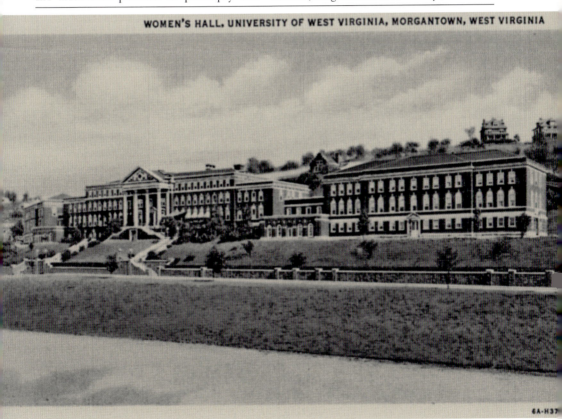

Education

87

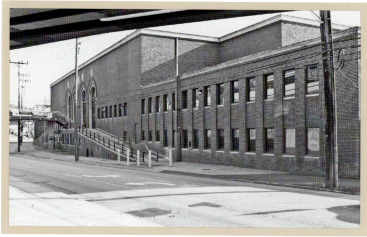

Stansbury Hall, located on Beechurst Avenue, opened its doors in 1929 as the West Virginia University Field House. The building was renamed to honor Harry Stansbury, who was athletic director at the college for over 20 years. Construction cost roughly a quarter-million dollars, and the hall held over 6,000 people. For nearly 40 years, Stansbury Hall was the venue for West Virginia University's home basketball games, including those featuring legendary players Jerry West and Rodney "Hot Rod" Hundley. In 1970, the basketball team relocated to the new coliseum on the Evansdale campus. Today, Stansbury Hall houses the ROTC program, the philosophy department, West Virginia University Writing Center, the liberal studies department, and religious studies. (Rodney Pyles.)

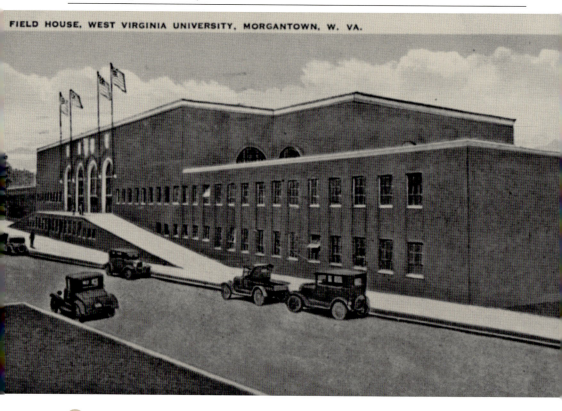

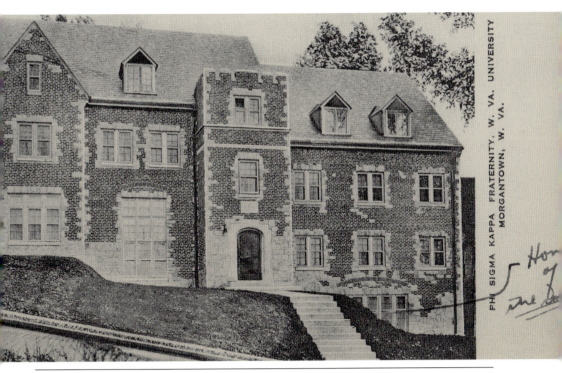

Phi Sigma Kappa first started at West Virginia University in 1890. Its house was constructed between 1929 and 1931 at 672 North High Street, the same spot where the fraternity was founded and where the current house is located. The new house cost over $55,000 to construct. In 1996, the fraternity built an alumni hall addition and unearthed the stone foundation of the original fraternity house. It is now the cornerstone of the alumni building. Morgantown's own Don Knotts, a legendary star of television and film, was a member of the 1946 Phi Sigma Kappa pledge class. (Rodney Pyles.)

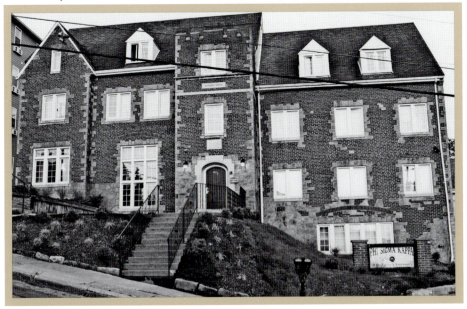

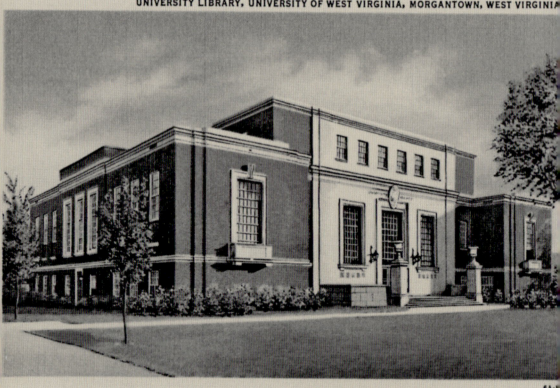

Construction was completed on Wise Library in 1931. The library outgrew its original home in Stewart Hall. The library is named after Charles C. Wise Jr., a West Virginia University alumnus, in acknowledgment of his generous donation of over 4,000 acres of land to the West Virginia University Foundation. In 2002, the library underwent an extensive renovation, and a new addition is connected to the original structure by an atrium. The library has over 300,000 books and multiple special collections and is home to the West Virginia Collection. A wonderful research facility, the library is open not only to West Virginia University students but also to the public. (Rodney Pyles.)

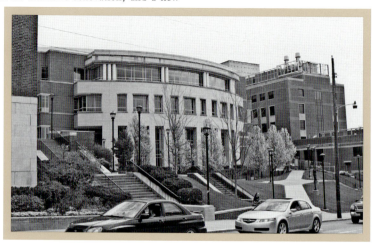

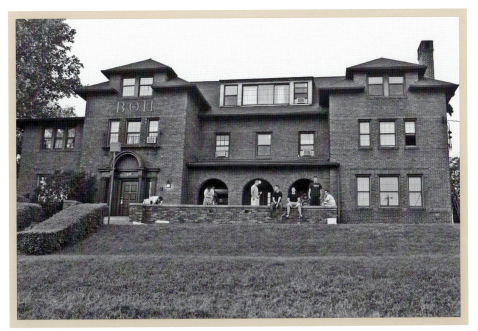

Beta Theta Pi fraternity house was built in 1930 at 225 Belmar Avenue. It was the first fraternity formed west of the Allegheny Mountains and the Mississippi River. The West Virginia University chapter was founded in 1900. In 2007, the house underwent a major renovation. (Rodney Pyles.)

BETA THETA PI FRATERNITY, W. VA. UNIVERSITY MORGANTOWN, W. VA.

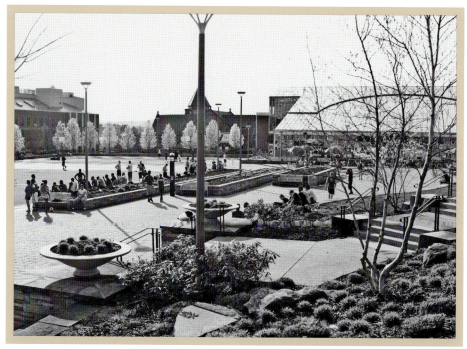

This 1956 picture captures the aftermath of the Mechanical Hall fire at its third location. The first Mechanical Hall was constructed along the Monongahela River in 1894 and served as a laboratory for the engineering program. The second Mechanical Hall was located at the site of today's West Virginia University's student center, the Mountainlair, and in 1899, it was the first of the Mechanical Halls to burn. In 1902, the subject of this picture, the third Mechanical Hall, was built. The Mountainlair parking garage occupies the site presently. (Rodney Pyles.)

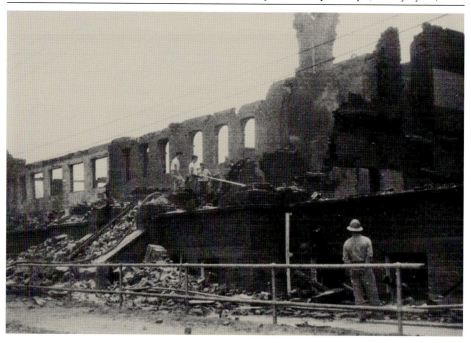

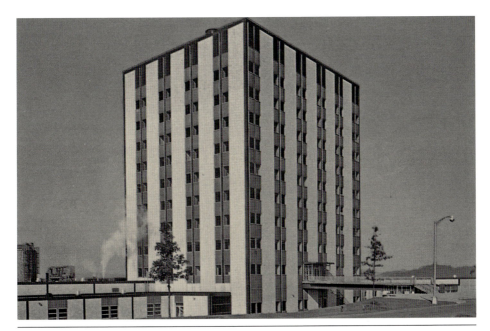

The Engineering and Sciences building on the Evansdale Campus opened in 1961 as a replacement for the Mechanical Hall that burned down in 1956 on the downtown campus. Work started on the 11-story building in 1959. In 2007, the building gained a four-story addition and is now called the College of Engineering and Natural Resources. In 2011, over $150 million was approved by West Virginia University's Board of Governors to renovate the Evansdale campus with a mandate to incorporate architectural details that would tie the new construction in visually to the downtown campus. The transformation will include a new building for the College of Physical Activity and Sport Sciences, a new engineering and sciences building, a new agricultural sciences building, and a greenhouse. (Rodney Pyles.)

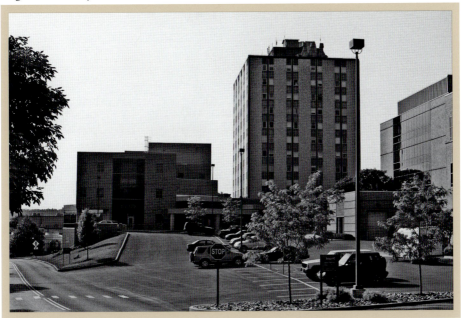

EDUCATION

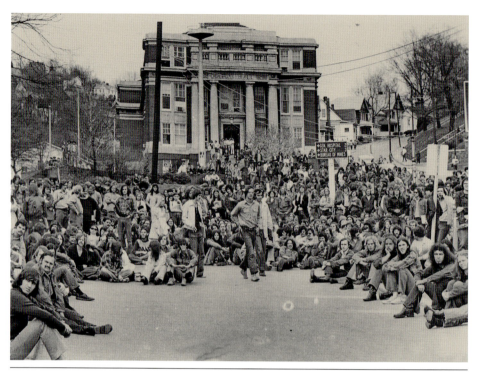

Students protest the Vietnam War in front of Oglebay Hall in May 1970. A few days earlier, four students had been killed on the campus of Kent State during a protest of America's recent invasion of Cambodia, and tensions were running high. Comparatively speaking, the West Virginia University affair was relatively calm, but police still used pepper spray and tear gas to disperse the crowd. West Virginia lost 711 men during the Vietnam War, a higher percentage per capita than any other state. Although it was constructed in 1917 and is on the National Register for Historic Places, Oglebay Hall is far from outdated, having undergone a $23 million renovation in the early 21st century. Because of its environmentally sensitive and sustainable features, it is also recognized as a LEED (Leadership in Energy and Environment Design) building by the US Green Building Council. (Bill Rumble.)

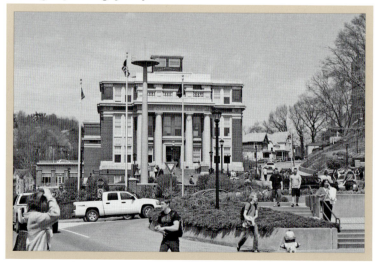

Nestled in a small valley below Woodburn Circle in the 1970s is the old Mountaineer Field, which seated over 38,000 spectators. The original field served the college from 1924 to 1980, when the new Mountaineer Stadium was constructed near Evansdale campus on the site of the old Morgantown Golf Course. The new Mountaineer Stadium, which cost over $22 million to build and seated over 50,000, opened on September 6, 1980. It has been expanded and upgraded throughout the years. It is the largest on-campus field in the Big East Conference, and its capacity has been expanded to seat over 60,000 people. After a generous donation in 2004 by Milan Puskar (founder of one of the area's leading economic powerhouses, Mylan Pharmaceuticals), the field and stadium were once again renovated and renamed Mountaineer Field at Mylan Puskar Stadium. (Rodney Pyles.)

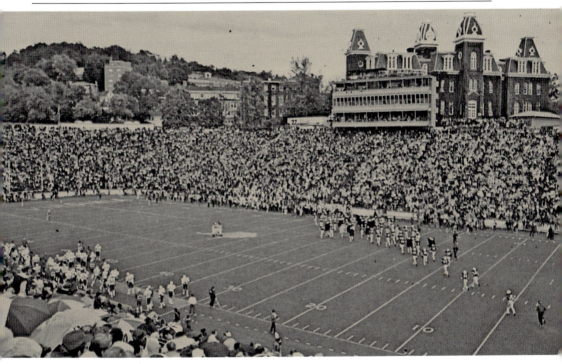

EDUCATION

www.arcadiapublishing.com

Discover books about the town where you grew up, the cities where your friends and families live, the town where your parents met, or even that retirement spot you've been dreaming about. Our Web site provides history lovers with exclusive deals, advanced notification about new titles, e-mail alerts of author events, and much more.

Arcadia Publishing, the leading local history publisher in the United States, is committed to making history accessible and meaningful through publishing books that celebrate and preserve the heritage of America's people and places. Consistent with our mission to preserve history on a local level, this book was printed in South Carolina on American-made paper and manufactured entirely in the United States.

This book carries the accredited Forest Stewardship Council (FSC) label and is printed on 100 percent FSC-certified paper. Products carrying the FSC label are independently certified to assure consumers that they come from forests that are managed to meet the social, economic, and ecological needs of present and future generations.

FSC
Mixed Sources
Product group from well-managed forests and other controlled sources

Cert no. SW-COC-001530
www.fsc.org
© 1996 Forest Stewardship Council

Find Your Place in History.